THE PHOTOGRAPHER'S GUIDE
TO GETTING & HAVING
A SUCCESSFUL EXHIBITION

Distributors to trade:

Robert Silver Associates
307 East 37th Street
New York, N.Y. 10016
(212) 686-5630

THE PHOTOGRAPHER'S GUIDE TO GETTING & HAVING A SUCCESSFUL EXHIBITION

THERE IS MORE TO AN EXHIBIT THAN MEETS THE EYE

Robert S. Persky, *1930-*

The Photographic Arts Center
New York, New York

Published by:
The Photographic Arts Center
127 East 59th St.
New York, N.Y. 10022
(212) 838-8640

Printed and bound in the United States of America

Library of Congress Cataloging-in-Publication Data

Persky, Robert S., 1930-
 The photographer's guide to getting & having
a successful exhibition.

 Bibliography: p.
 Includes index.
 1. Photography--Exhibitions--Handbooks,
manuals, etc. I. Title. II. Title: Photographer's
guide to getting and having a successful exhibition.
TR6.A1P47 1987 770'.74 86-30639
ISBN 0-913069-10-8

Table of Contents

Preface

Two years prior to the date this manuscript was sent to the printer, a letter arrived on the author's desk. It was from Bombay and asked, "How does one get an exhibition in the United States?" The response would have required a long letter, and the author looked through his extensive library for a book to recommend. Finding none, he proceeded, without success, to look through a library card catalog as well as in the bibliographies of books on the business of art and photography.

Locating no appropriate book, he placed the letter on his pile of unanswered mail. The letter remained in the unanswered stack for several weeks. By that time, the idea of writing this book had germinated. You are reading the answer to the Bombay letter.

The dictionary definition of exhibition is "a public show or display, as of art." What the eye sees is your exhibition, but it is the unseen that makes the difference between a successful exhibition and a potential disaster. The unseen often makes the difference between getting a rejection and getting an exhibition.

A photography exhibition is the culmination of talent, determination, patience, promotion, luck and timing. Even when all of those factors work together, a successful exhibition requires an understanding of the mechanics of publicity, reviews, promotion, invitations, and agreements with exhibition spaces.

This guide is written to assist you in getting and having a successful exhibition. Although written from the photographer's point of view, it is helpful to any person responsible for an exhibition space.

The chapters on announcements and invitations, publicity, agreements with exhibition spaces, catalogs, reviews, special events, and budget are equally applicable to the management of a gallery, a museum, or alternative exhibition space.

To the extent possible, the organization of the guide is chronological. The phrase "to the extent possible" is used because, of necessity, some activities take place simultaneously. This guide should be read once before embarking on your quest for an exhibition, and it should be referred to at each stage of your planning.

Since you may refer to specific sections without reading the complete guide, certain important points, applicable to more than one topic, have been repeated in each appropriate section.

Reference works mentioned in the text are listed in the bibliography together with the names of the publishers and dates of publication. A majority of the reference works containing names and addresses are issued annually. Be certain to consult the latest edition of each reference work.

The table of contents serves as a road map for getting and organizing your exhibitions. The index should be used to locate the page reference to particular topics.

Appendices A through F contain information on sources, a checklist, a model agreement, forms of announcements, and a form of press release.

Good luck . . . I'll be looking in my mail for your exhibition announcement!

New York R.S.P.

Your Reasons for Having an Exhibition

The primary reason for exhibiting your work is to have other persons view the results of your creativity. However, you may have one or more other valid reasons or motives for having an exhibit.

Secondary reasons include:

1. to sell your prints
2. to make an artistic statement
3. to make a social statement
4. to obtain comments and reviews
5. to promote your career as a photographer
6. to stimulate your creativity
7. to promote your career in an arts-related area
8. to help establish that your artistic endeavor is not merely a hobby
9. to create dignified publicity for a business or profession
10. to take an ego trip

Although, on first glance, it may seem that the motives for having an exhibition fit in neat categories, you will soon realize that they overlap and reinforce one another.

The sale of your prints may result from any exposure of your work to a potential purchaser. The exposure may occur in your studio or home, in

the residence of an owner of your work, or in an exhibition space. The greater the number of people who see your art, the greater is the opportunity for a sale to take place. A sale not only results in the payment of money, but it is also a validation of your work. Van Gogh might have been happier if his paintings had sold during his lifetime.

Although sales have their value in both economic and psychological terms, there are other motives which may take precedence.

The early proponents of each school of painting, photography, and sculpture usually are concerned with making artistic statements. They see their work and desire others to see their work as different, and perhaps better, than that of their predecessors. The artistic statement may be as important, or even more important, than the sale of their work. If their work is innovative, an exhibition will be an artistic statement marking a departure from the traditional.

Since photography may be used to record social conditions and historical events, your motive for an exhibition may be to make a statement in which the art is secondary and what is viewed is primary. The horrors of war, starvation, disease, slavery, and social conditions have all been portrayed in exhibitions.

One of the motives which overlaps into all of the others is "to obtain comments and reviews." The comments of reviewers, your contemporaries in the art world, and persons who attend your exhibit may be of great value to you. The praise of family and close friends may be tempered by your relationship, and you will hear more objective comments from the lips of strangers. Formal reviews may be euphoric or caustic. Nevertheless the fact that you are accorded a review is, itself, a positive factor. Critics will often ignore the emerging

artist, and the existence of even a single review will often provide the stimulus for subsequent reviews.

It is rare, in the history of art, that an artist is "discovered" in the absence of his or her work being exhibited. Sales may take place directly from your studio, but the number of studio viewers over a period of a year cannot be very great. If large numbers do come to your studio, it will probably interfere with your work. The public exhibition space provides an opportunity for your art to be viewed by a substantially larger number of persons and by individuals with whom you have no personal contact. The fact that you have had one or more exhibitions is a positive factor in the world's perception of you as an artist.

You may be a prolific creator of work, in which case you can skip to the next paragraph. However, for those of you who work in spurts, an exhibition may provide a stimulus to your creativity. Having set the date you will find that the desire to show more work in your current style with new concepts, not yet executed, will result in great productivity.

Persons who create art often earn rent money in art-related services. You may be a commercial photographer, designer, art director, account executive, picture editor, teacher of art, commercial artist, retoucher, restorer, gallery director, curator, or editor. An exhibition of your photography may serve a beneficial business or career purpose.

For instance, the opening is a business party. The exhibit presents an opportunity to invite colleagues and those who use your photography-related services. The time frame of the show permits you to contact clients and potential clients by inviting them to view the exhibition. Exhibitions result in new contacts, renewed business relationships, increased income, books, posters, and future exhibitions.

The government takes a dim view of deducting the expense of a hobby but does permit the deduction of expenses of a business. One of the steps in determining whether your photography is a hobby or a business is answering the question of whether you have sold your work or made attempts to sell it. An exhibit is good evidence that your photography activities comprise a business. Copies of press releases, listing notices, announcements and invitations all add substance to your deductions. Reviews, sales, and agreements relating to consignment and sale are demonstrative evidence that will tip the scales in your favor.

Although lawyers, accountants, doctors, dentists, and other professionals are now permitted to advertise, many are reticent about newspaper ads, direct mail, radio and television commercials, and billboards. As a professional whose work is on exhibition, you can obtain the benefits of advertising through public relations and publicity. Newspapers, magazines, professional journals, radio, and television are often receptive to a story about the accountant, lawyer, dentist, or doctor who paints, photographs, or sculpts. The story will often illustrate the difficult life of a successful professional possessing the artistic sensibilities evidenced by the work on display. Being visible is often as important as being expert in your profession, and an exhibit can provide dignified visibility.

Ego trips take many forms. One of the most constructive is the sharing of your photography with others through an exhibit. It is an activity which is harmful neither to others nor to you. Should you be unable to find one or more reasons among the first nine, do not despair. You can have a pure, unadulterated ego trip!

You will probably find that you have several motives for exhibiting your photography. You may even have one or more motives that are not included in our list.

The bottom line is that your exhibit will result in benefits to you whether or not you devote all of your time to being a creative photographer.

Your Preliminary Preparation

Your involvement with the creation of art may be motivated by the desire to create for yourself, but eventually you will think about an exhibition. The idea of an exhibition will arise either spontaneously or by virtue of a suggestion by a teacher, friend, relative, or the decision-maker at an exhibition space.

During our discussion of exhibitions we have adopted the use of terms designed to encompass the varied nature of potential exhibition spaces. Thus the phrase "exhibition space" encompasses commercial galleries, co-op galleries, subsidy galleries, museums, and alternative exhibition spaces. The term "decision maker" encompasses gallery directors, curators, co-op committees, building owners, club managers, and any person who is in a position to grant you permission to use a space for your exhibition.

If the idea of an exhibition is appealing and begins to germinate, you have two options. You can either hire an exorcist to rid you of the exhibition devil or commence your preliminary preparation.

Preliminary preparation is important because it provides the foundation for getting and having a successful exhibition.

The first question to ask yourself is: "What am I going to exhibit?" One of your prints may have won first prize in a contest, but decision-makers at exhibition spaces are not interested in an artist with one great image. Do you have ten other prints that, in your opinion, are the equal of the award winner?

The print you presented to a business colleague has been hung in the reception area and receives frequent accolades. Is it representative of a larger portion of your work?

Decision-makers at exhibition spaces look for a body of work that is cohesive in artistic concept, quality, and execution. The French adopted the word for work, "oeuvre," for the concept of the body of creative output of writers, artists, and composers. "Oeuvre" has been incorporated into the language of the English-speaking art world.

If your oeuvre, at the commencement of your preliminary preparation, consists of only a few pieces, the initial part of your plan must be to augment your oeuvre.

If, as with most artists, your style and point of view have gone through periods of growth and change, you may find that although you have a large oeuvre, it is only your most recent work that you desire to exhibit. You should, as part of your preparation, create a sufficient number of pieces to constitute a solo exhibition or a major fraction of a group exhibition.

Portfolio Selection

The problem for the majority of photographers will not be having too few pieces; it will be having too many.

Your first task will be to select what you want to include in your exhibit. Although the decision-maker at your exhibition space may choose other pieces, you must first decide what to show the decision-maker.

You should select a cohesive group that represents the best of your

work. Be ruthless in your selection. Do not choose anything for which you have to apologize.

Reproduction of Your Work

The second task is to reproduce your work in a form that is easy to carry, or otherwise deliver, to decision-makers for review. The reproduced work is your portfolio. Your portfolio is what must intrigue the decision-maker.

Photographers who work in black and white or color negative film present a portfolio of prints. Their only problem arises when the prints they desire to exhibit are too large to carry or mail.

The solution is to make a set of smaller prints. If the impact of image size is important you can use slides to project the image at the appropriate screen size.

Photographers who work with positive film often use original or high-quality duplicate chromes as their portfolio. Chromes are convenient to mail and carry but the decision-maker is deprived of the opportunity to judge print quality. A portfolio of prints is preferable, particularly when your work is being viewed by a decision-maker at a commercial gallery or museum.

If your work is composed of large photographic constructions you will require a photographic reproduction of the originals.

Slides are recommended because the viewing light passes through the slide and usually results in retaining the color saturation of the original. Prints are viewed with reflective light, and unless of the highest quality, they may lose color saturation or detail.

If your work is "one of a kind," i.e., a hand-tinted print or a Polaroid print, you will have to photograph it or risk carrying about the original. Photographing a photograph presents special problems of lighting, but there are certain rules which are common to all art photography. You must use the proper equipment. A hand-held camera is not the proper equipment even if your original was taken without a tripod!

The first rule to be followed in photographing flat art is that the camera lens and film plane must be absolutely parallel to the original. That is almost impossible to accomplish without a tripod. The result of not following this rule is that your work will look distorted on the slide or print.

The second rule is that flat or two-dimensional art must be evenly lit. Two or three lights color-balanced for the film are required. A strobe or flash will result in uneven light and, in most instances, a hot spot which will "wipe out" a portion of the image. The source and placement of light will affect color intensity and the amount of detail captured.

If your print is under glass, make certain that neither you nor the camera or lights are being reflected. One technique to eliminate reflections is to place the light sources in front of the camera. A second is to use polarizing devices.

It is a good idea to bracket your shots so that you have three different exposures of each work from which to choose.

The photographing of art requires skills which are slightly different from those required in taking original pictures.

If you desire to learn to photograph art, a good starting point is the article by Ed Peterson entitled, "Quick & Easy Way to Photograph Art," which appeared in the July 1977 issue of *Modern Photography*. If your library does not have that issue, try a store specializing in used magazines. It is replete with practical advice, diagrams of camera and lighting positions, and suggested equipment.

Your Resume

Along with your portfolio, it is essential to have a resume. Decision-makers want to know about you. The resume is particularly important when you are not personally presenting your portfolio and is helpful even when you are making your own presentation.

Your resume will differ from a job or professional resume in that it will contain only art-related information. Other activities are of little interest to a decision-maker at an exhibition space unless it is clear that the decision may be based on the other activity . . . e.g., if the space is a private club, it may be important to note that you are a member, but that also can be accomplished in a covering letter or in conversation.

There is no single form of resume. Mandatory information consists of items 1 through 3 on the following list. Items 4 through 10 should be supplied if you have information which would be helpful in convincing the decision-maker.

1. Your name
2. Your address
3. A phone number where you can be reached during the business day
4. Brief biographical data
5. Your formal photography and/or art education, if any
6. Exhibitions in which you have shown
7. Awards you have received for your photography
8. Collections in which your work appears
9. Writings by you in the field of photography
10. Present or past sales representatives

Needless to say, the resume should be neatly typed and cleanly reproduced on a good-quality paper.

Items 1 and 2 are self-explanatory. Item 3 requires a phone number where you can be reached during the day. If you are a full-time photographer, the phone at your studio is the one which should be used. If, like many photographers, you earn your rent money by other endeavors, you should list your business phone. If receiving personal calls is not permitted at work, list your home phone number. If no one is there during the day to answer the phone, invest in an answering machine. Decision-makers at exhibition spaces are occupied by many tasks. If they want to reach you, they should not be frustrated by an unanswered phone. They keep normal business hours, and it is to your benefit to be accessible by phone.

A section devoted to biographical data need not track every educational institution you have attended and every job you have held. Your highest level of education and your present position are sufficient.

If there is something in your biographical data which relates to your art, this is the place to relate the facts. If, for instance, you have lived in Japan and your work reflects a mixture of oriental and western art, by all means high-light that fact.

Item 5 relates to your formal art education. While formal training is not necessary in order to get an exhibition, the fact that you have studied at a particular institution or under a particular teacher, may have meaning to a decision-maker. If your training included being an assistant or an apprentice, tell with whom and for how long.

Item 6 is self-explanatory. While it is probably better to have had past exhibitions, it is not critical. If your resume is devoid of exhibitions, you may want to consider entering what are known as "open exhibitions." Open exhibitions are exhibitions that permit the showing of work by anyone paying a modest registration fee. The exhibition may be limited to residents of a particular area, those of a particular age group, or members of a particular profession. Usually you are limited to submitting one work or at most a few pieces, but the experience will be instructive. It will add "prior exhibitions" to your resume. A list of open exhibitions may be found in the *American Art Directory*.

Awards you may have received for your art should be set forth in item 7. A first prize, even at a village art show, is some evidence that others appreciate your work. The fact that you have won a major prize in a state or national contest is also significant since the judges in such contests are often respected persons in the art field. As part of your preliminary planning, you should consider entering several contests.

The data on collections in item 8 refers to museum and other not-for-profit institutions. The names of prominent private and corporate collectors of your work should also be included. Your brother and mother do not count!

During your preliminary preparation you can attempt to have your work placed in significant collections. Remember that the information sets forth only the ultimate fact that your work is in the collection. Whether it was your donation, or that of a third party, is not evident. It is the acceptance which is important. The vast majority of museums and not-for-profit institutions are selective in what they will accept as donations. Major museums may even turn down lesser works by well-known artists. Nevertheless, if your work fits within the category of work being collected, you may be able to arrange for your work to be accepted.

Many museums have regular review procedures for new work. Since most museums have limited budgets for the acquisition of new work, you can submit work with a notation that a third party is willing to acquire the work from you and donate it to the museum, or that you are willing to make a donation. Personal contacts with museum directors, trustees, and curators are helpful in arranging donations.

Important private collectors are not immune to acquiring work they like, either as gifts or at bargain prices. It is not suggested that you march up to private residences or offices without an appointment, ready to leave your art. Try to find a mutual friend, advisor, teacher, or dealer who is willing to make an introduction.

Your resume reflects only positive facts. The fact that you didn't win a contest or that your offer to donate art was not accepted remains in your head. Don't hesitate to act. Only your successes are set forth in your resume.

If you have published an article relating to your own work or there has been an article published about your work, include the title, the publication, and the date of the publication in item 9.

Photographers are not necessarily good writers, but if you can write and haven't previously published, try writing and submitting the piece to an appropriate publication. Having an article published either on your work or on the field of your work is a plus.

If you are presently represented by an exhibition space, or have had such an affiliation, make that fact known in item 10. That others have thought your work worthy of being offered for sale is a positive factor.

Your Mailing List

Your preliminary preparation should include the compilation of a mailing list. Your mailing list is a collection of the names and addresses of those whom you particularly desire to attend your exhibition.

Depending on your reasons for exhibiting, the list may contain, in addition to friends and family, potential business clients, colleagues who may refer work to you, persons you would like to meet, and critics.

Your mailing list is best compiled over a period of time. Even if you are super-organized and have everyone in your address book or in a card file, you will want to transfer your list to a mechanical or computerized addressing system.

If you have a personal computer or word processor, you may want to enter the names so as to be able to address envelopes or print mailing labels. If your list is very large or you don't have access to a personal computer or word processor, you can have a letter shop transfer your list to an addressing system. If your list is short, you probably will not find hand-addressing onerous.

The earlier you commence list assembly, the better the chance that no one who should be invited will be inadvertently omitted.

You will need the list prior to ordering invitations and announcements in order to determine the quantity to be printed.

When you order invitations and announcements remember to obtain the correct-size envelopes before the invitations are delivered. The addressing can commence before the invitations are ready. When addressing by hand, obtaining the envelopes early eliminates the need for a crash program. If your exhibition space is taking care of the mailing, they will want you to supply your list, labels, or addressed envelopes several weeks before the opening.

Summary

Preliminary preparation increases your chances of obtaining an exhibition. Once you have an agreement to exhibit, the preliminary planning will facilitate the success of your exhibition. It is never too early to commence preliminary preparation!

Your Contacts with Exhibition Spaces

Having decided that you have one or more reasons for having an exhibition and putting together a portfolio of work, the time has arrived to commence contacting exhibition spaces.

Exhibition spaces can be divided into two categories. The first category is composed of all spaces already set up for the exhibition of art. They include commercial galleries, artist co-ops, museums, university galleries, and other not-for-profit spaces.

The second category consists of all the spaces which may be used for the exhibition of art but which have not been designed as exhibition spaces. In this guide they are referred to as "alternative exhibition spaces."

While it is possible that the first exhibition space you contact will welcome you with open arms, you should be prepared to make multiple contacts before finding a space. It is all too easy to make one contact, obtain a negative response, and abandon your goal. You should be prepared for both rejection and your next contact.

First Stage Planning

The first stage in your quest is some intelligent planning. Planning commences with making a list of the exhibition spaces that will consider your work. It does little good, for instance, to contact galleries that show only oil paintings if you are a photographer. You can eliminate those museums that never exhibit work other than that which is in their permanent collection.

Your list should commence with exhibition spaces in your community. If your list does not consist of at least five potential spaces, augment the list with spaces in the nearest metropolitan area. If your finances are sufficient for travel, you can include spaces anywhere in the country.

Your list should include not only the name and address of the exhibition space but also the phone number and the name of the person who is the decision-maker.

Your second step is to learn the process that each space on your list uses to review portfolios. In the case of commercial galleries, you will find that some galleries will look at any portfolio that is left with the staff while others require a recommendation from an artist already represented by the gallery. A few, but not all, of the larger and more prestigious galleries will not look at the work of emerging artists. Museums vary from those with regularly scheduled reviews to no reviews except by introduction. The time, expense, and effort of making phone calls or writing letters will pay off. You will save yourself time, energy, money and rejection if you do your homework and ascertain the facts for exhibition spaces on your list.

If you live in a small town or city, you are probably already familiar with all of the exhibition spaces and what they exhibit. If you reside in a metropolitan center, you will have to do research before commencing your list of potential spaces.

You can begin with the listings of art galleries and museums. First try the yellow pages of the appropriate phone book. Exhibition listings and advertising in local newspapers are additional sources of information. *Gallery Guide* is a monthly regional guide to exhibitions. You can usually obtain a copy of *Gallery Guide* at galleries in major cities. If you don't reside near a major city, you can obtain a copy by mail from the publisher. *The Annual Guide To*

Galleries, Museums, & Artists is organized by state and city. It is particularly useful because it gives a brief description of the type of art displayed and the name of the director. Magazines and newsletters dedicated to your art form are also good sources for preliminary information. Photographers can commence their list with a copy of *The Photographer's Complete Guide To Exhibition & Sales Space.*

Local organizations of artists can be helpful in suggesting spaces, particularly co-op galleries and alternative spaces.

No one source contains the name of every exhibition space. Even if there were a definitive work, you would find that new galleries had opened and a few had closed by the time the definitive source was off the press. Since new galleries are often most receptive to reviewing work, be certain to check current listings of exhibitions and advertisements for spaces that are not listed in the phone book or in one of the directories.

While it is not necessary at this stage of your planning to be familiar with the physical layout of each space on your list, it is helpful. If possible, you should visit the spaces on your list. It will give you a better understanding of the nature of the work exhibited and, in some instances, save you time if the physical layout is inappropriate for your art. For example, in newer buildings, the ceilings may be too low for large canvases.

Second Stage Planning

Having done your initial homework you should now have before you a list of potential spaces, the name of the decision-maker at each space, and the method of review for each particular space.

At this point, if you are unacquainted with the decision-maker at a

potential exhibition space, you should attempt to find someone who does know the decision-maker. Other artists represented by the space, art teachers, critics, and even personnel from other exhibition spaces are often willing to make a phone call or write an introductory note.

The reason for the introduction is that it will set you apart from all those who have contacted the space "cold." Decision-makers at exhibition spaces are subject to human responses. A personal introduction from someone they respect can be a positive factor in getting attention for your submission. An introduction may not guarantee an exhibition, but it usually results in serious consideration.

It is not mandatory that you have an introduction. It is necessary only in those instances where the space reviews only after an introduction.

If you are unable to come up with an introduction, other than in those instances where an introduction is mandatory, proceed to follow the space's review process. If they ask that your portfolio be left for a week, or sent in with return postage, be prepared to comply. Since many spaces require that the portfolio remain with them, and are not always prompt in making returns, you should have several portfolios. Multiple portfolios are particularly useful if you are visiting another city and have made several appointments.

How Not to Contact Exhibition Spaces

You will spend both time and money in contacting exhibition spaces. Spend your time and money wisely. Avoid the common mistakes that either result in a waste of your time, energy, and money, or increase your chances of experiencing disppointment.

The first and most common mistake is the failure to do your home-

work. It results in your spending postage on mailings to exhibition spaces that either don't exhibit and sell photography, or don't exhibit and sell contemporary work.

Several sources sell lists of exhibition spaces printed on mailing labels. If you buy a list, it may save you from typing labels, but unless you know the facts concerning a particular exhibition space, you should not use the label. It may be appealing to skip your homework, but it is expensive since you will be mailing to spaces that have no interest in your work or deal only in 19th century prints.

The second common mistake is the "cold call." A cold call is your appearance at an exhibition space, without an appointment, seeking a portfolio review. Don't expect to be welcomed and to have your portfolio reviewed. Unless the space has a policy of permitting cold calls at specific times, cold calls are almost never appropriate. You will irritate decision-makers who will, because you appear without an appointment, come to the conclusion that you are rude, arrogant, overbearing, foolish, inconsiderate, disorganized, ignorant or a combination thereof.

Exhibition spaces are rarely overstaffed, and the cold call will interrupt a sales effort, the writing of listing notices, the hanging of an exhibit, the preparation of a mailing, the paying of bills, the answering of correspondence or luncheon plans.

You will receive the most serious and thoughtful consideration of your portfolio when you arrive with an appointment.

A third common mistake is a close relation of the cold call. It is the phone call announcing the fact that you have arrived in the city from a distant place and require an appointment. The city in which you have arrived is probably a major art center. It has been the destination of thousands of artists each

year during the past decade. A large percentage of those artists have tried the same gambit. You will not receive a large number of appointments. If you are planning to travel, you should make your appointments by mail or phone several weeks before you leave. If you use the mails, have the courtesy to enclose a stamped self-addressed return card or envelope. You increase your chances of a timely response if you eliminate as much work as possible for the decision-maker.

If you insist on cold calls or the "I'm in from Tibet!" gambit, at least learn what days the space is open. In New York, for instance, most galleries and museums are closed on Mondays. Remember that summer is the time when gallery and museum staff take their vacations. Even if the space is open, you will find that many decision-makers are away.

A fourth common and fatal mistake is to present samples of your prints or slides that are not of the highest quality. The photographer making an excuse for the condition of a print is, in the mind of the decision-maker, someone who either cannot produce work of exhibition quality, or who does not respect his or her own work. If you are on a trip, and visiting several spaces, you should have backup work for use in the event that your work is damaged in transit or in handling.

A fifth common mistake is to have biographical materials which are poorly reproduced. Use a good-quality paper and have your biographical data neatly typed. Reproduce it on equipment that yields a clean and clear copy. A business card is not critical, but it is an inexpensive and professional detail. When traveling, take a copy for each space you plan to visit. Send a copy along with each portfolio you submit by mail.

Never, but never, submit the only copy you have of a resume, review, article, or recommendation. Always have at least one copy of everything in your file. The mails deliver 99.9% of everything. The other .1% are lost, chewed up in canceling equipment, or otherwise accidentally destroyed. Even when delivered in mint condition there is a chance that your materials will languish on the desk of the decision-maker for an eternity or be returned with coffee stains.

A sixth common mistake is the handwritten letter seeking an appointment. Have stationery printed with your name, address, and phone number, and send typewritten letters. Photographers who produce beautiful work often have illegible handwriting. Avoid the temptation to use a form letter which has been run off on a copying device. It is always obvious, and the decision-maker knows that you have not selected his gallery but sent out a mass mailing. Even if you send out a large mailing, each letter should have the appearance of a personal letter. The task is not so onerous as before the advent of the word processor and home computer.

Coping with Rejection

I have no doubt that, at the moment the first caveman scratched a drawing on limestone, there was a critic standing by to voice a negative comment.

You will be neither the first nor the last artist to experience rejection. Statistically every artist receives more initial rejection than acceptance. The fact to remember is that you require only one space to have your exhibition. No artist has ever received acclaim from everyone who viewed his or her work.

The best way to handle rejection is to immediately make another contact. Your list of spaces to contact should always contain at least three

more potential exhibition spaces. If you experience rejection, you should be ready to proceed to contact the next name on your list.

Exhibiting your work means exposing it to public opinion and risking rejection. Exhibition space decision-makers often reject work they admire for reasons unrelated to the aesthetic quality of the work. One example is rejection because the style is too close to that of a photographer already represented by the space. Often a decision-maker will continue to look at portfolios even when there is little opportunity to augment the number of artists exhibited by the space.

In addition to having the next exhibition space in mind, heed the following observations:

1. Rejection is only one person saying "No" to your work.

2. Be realistic. Dreaming of immediate and universal acceptance may be fun but is unrealistic.

3. Have a support system in place. Share your feelings with other artists, family, or friends.

4. Don't permit rejection to make you angry. Treat it as a challenge. Take constructive action.

5. Acknowledge that luck and timing do play a role. You may arrive for a portfolio review just after the decision-maker has learned of the cancellation of an exhibit. The anger and frustration may be vented on you! In the alternative you may find that you will be the replacement for the cancellation.

Rejection may also arrive in the form of overheard comments at your exhibition or in reviews. The first four observations listed above are equally applicable to comments and reviews!

Co-op Galleries

One method to finesse rejection is to join a co-op gallery that offers an opportunity, to all its members, to exhibit. Although some co-op galleries go through a screening process, your commitment to your work is usually sufficient to obtain approval of the membership committee.

A few co-op galleries have been organized by groups who feel deprived of equal opportunity at commercial galleries and museums. They usually, but not always, limit their membership to minority or perceived minority groups. Some co-ops limit membership to those working in a particular art form . . . e.g., photography.

Co-ops operate in differing ways. At some the walls are always available to those who are willing to pay exhibition fees; while at others, the dues are sufficient to pay expenses, and exhibitions are chosen by rotation or committee.

Some co-ops even permit non-members to exhibit under a category of "visiting or guest exhibitor."

The most important fact about a co-op may be its location. If sales are important to you, you will be concerned with whether the co-op is in a gallery district or on the fringe of a factory area. If your reasons are other than sales, consider whether the location is a positive or negative factor.

While co-op spaces may not have the prestige of a major museum or a well-known gallery, they serve a valuable role in the art world. Co-ops permit the public an opportunity to see work that might not be otherwise exhibited. They afford emerging artists a chance to exhibit and sell. A co-op may be exactly the right space for you.

Subsidy Galleries

Some galleries work with artists on a subsidy basis. They are hybrids in the sense that they have characteristics of both co-op and commercial galleries. Subsidy galleries provide all of the services of a commercial gallery, including sales staff, but they do not run the complete risk of overhead. The artist pays an exhibition fee or rent, thus providing a subsidy for the gallery. The fee or rent will usually cover a major portion of the space's out-of-pocket expenses for the period of the exhibition. A commission may be payable on work sold. The commission represents the profit to the gallery.

Artists have varying degrees of success with subsidy galleries in terms of sales. Depending on location, ambiance, and the services provided, you may find that a subsidy gallery is right for you.

Subsidy galleries usually do not identify themselves as such in exhibition advertising and listings. You will learn about them from other artists, from ads in art publications seeking emerging artists, or from information provided to you when you contact the gallery.

Subsidy galleries may be run by an entrepreneur who will permit anyone to exhibit, or by an art lover who exercises as much discrimination as a museum curator. The difference may be only one of available capital. Owning a subsidy gallery makes it possible for a person who desires to be in the gallery business to do so without a large bank account. From your point of view, an exhibition at a subsidy gallery may be identical to an exhibit at any other space except for the fact that your expenses will be larger.

If you have the funds, and are unable to obtain an exhibition at a commercial space or a museum, consider a subsidy gallery.

Alternative Exhibition Spaces

Alternative exhibition spaces are areas which are not set up for the exhibition of art but which may be adapted to the exhibition of art. You should view every enclosed space with unencumbered walls as a potential alternative space. Some alternative exhibition spaces that have been successfully used are

Libraries
Banks
University and college student lounges
Government building lobbies
Private office building lobbies
Train and subway stations
Private clubs
Community centers
Church and synagogue meeting rooms
Theatres
Recreational centers
Bookstores
Recital halls

Some alternative spaces regularly exhibit art even though they are not set up for exhibitions. A commercial bank on Manhattan's 5th Street, located in a building with several prestigious galleries, regularly exhibits art in its windows. Recently I observed that one of the major galleries in the building had taken over windows that had been used the prior month by an artist without a gallery affiliation. A savings bank in an area of the city totally devoid of galleries also regularly exhibits art in its windows. A major private office building in New York has one three-month exhibit each year, and others, on a sporadic basis, permit exhibitions.

Universities and colleges are amenable to student, faculty, and alumni exhibitors in student and faculty lounges.

Even supermarket windows, usually filled with food displays, have been used for exhibitions.

Private clubs, particularly when the subject matter of your art and the interests of members are parallel, are often agreeable to exhibiting your work in their public rooms. Horticultural clubs will favor plants and flowers; ethnic groups are partial to scenes or photographers from their respective homelands. Club members can often arrange an exhibit of their own work, regardless of subject matter.

Your research into possible alternative spaces should begin with exhibition listings and your own observation of what is happening in your community. You can ascertain which alternative spaces are being used and contact the decision-maker. Since alternative spaces may not exhibit with any frequency, you may have to check the listings and special events columns in local publications for a period of three-to-six months in order to assemble a reasonably complete list.

Exhibition spaces have directors, curators, or administrators as decision-makers. In dealing with alternative spaces there is no common title for decision-makers. If it is a bank, it will probably be the branch manager. If it is a private office building, it will be the building's managing agent or a representative of the major tenant. At universities and colleges it will be the individual in charge of the particular building or department. If it is a private club, it will be the club manager, the club president or perhaps an art committee.

You will probably have to make one or more phone calls before ascertaining whom to approach. If you receive a favorable response, you will find that you will be largely on your own in terms of hanging the exhibition, printing announcements, and listing notices. You may find that the alternative space has a public relations person who can assist in media contacts. Private clubs will place notices in their newsletters and bulletins and perhaps make a special mailing to their members.

In banks, clubs, and spaces with staff located in the area used for exhibitions, security will not be a major problem. In spaces where building staff is not posted, you must be concerned with the fact that your work may walk off the walls or, worse, be vandalized. The problem can be partially solved if your work is framed under glass and affixed to the wall with a hanging mechanism which does not permit it to be easily removed. Most alternative spaces, however, will not permit anything to be affixed to the walls that will leave marks or holes. Possible loss by theft or vandalism may be an acceptable risk in order to have an exhibition. You may have the budget to post a security guard during the hours the space is open to the public. As an alternative to a professional security guard, friends and family may be drafted into service.

When contacting decision-makers at alternative spaces, in addition to the usual personal information, you should mention any affiliation with the alternative space. Club membership, being a depositor at the bank, being a tenant or employee of a tenant in the building, may tip the scales toward a favorable decision.

Having received permission, choose your dates with care. Make certain that the alternative space will not be undergoing renovation during the

exhibition period. Obtain a letter from the decision-maker confirming the dates and permitting you access to the building in order to hang the show.

The use of an alternative space may result in a greater number seeing your work than if it were hung in a commercial gallery. Sales rarely result from alternative spaces because there is no sales staff. If you are interested in sales, a plaque with your name and phone number can be hung with the exhibition.

The location of an alternative space may be superior, for your purposes, to that of a gallery. If sales are not your primary reason for exhibiting, alternative spaces deserve your serious consideration.

Scheduling

Museums and well-established galleries often schedule exhibitions a year in advance. Major museum exhibitions are often scheduled several years in advance. Even when the decision-maker is enthusiastic about your work, you may find that an affirmative response is tempered by the fact that you will have to wait for a period of from six months to a year. Be patient. You can put the time to good use.

New galleries, co-ops, subsidy galleries, and alternative spaces may be more flexible in scheduling. Don't, however, jump at an opportunity to exhibit if you will not have several months during which to prepare. You may be tempted to accept a time slot which is 30 days off, but your reasons for doing so must be compelling!

Your Agreements with Exhibition Spaces

Do You Need a Written Agreement?

There is no topic that generates more heated discussion than the question of whether or not a written agreement is needed between an artist and an exhibition space. The controversy is fueled by a well-intentioned but erroneous concept. The erroneous concept is that, since the interaction between an artist and an exhibition space is based on trust, belief in the artist's work, a special relationship, or other personal synergism, then a handshake agreement is all that is required.

The problem with a handshake is that, although the parties think they have covered all the contingencies, they probably have not touched upon a majority of the problems that may arise. It is not suggested that either the artist or the exhibition space shakes in "bad faith." There are many events that can occur, having nothing to do with good faith, which have major economic and artistic consequences for each party.

For example, handshake agreements almost never contemplate the loss of the art by fire, theft, or vandalism. Who bears the loss? Is there insurance? Who pays the insurance premium? On a less dramatic note but one which may cause major friction . . . "Who hangs the exhibition?", "Who has final say on the way the exhibition is hung?"

In this chapter are listed the questions which should be answered before you reach an agreement with an exhibition space. After you read this chapter it should not take much persuasion to convince you that the answers should be reduced to writing.

All of the suggested questions are appropriate to ask. The answer will differ depending on the identity of the exhibition space.

There are no right or wrong answers. The only "wrong" is to fail to ask, discuss, and agree.

Following is the list of the questions that should be asked. You or your lawyer may have other questions, but these are important to everyone.

1. What are your exhibition dates?
2. Is your exhibit a solo or group show?
3. Who pays the cost of delivery and return of your art?
4. What is being exhibited (identity and number of pieces)?
5. Who is responsible for framing, pedestals, or special lighting?
6. Who is responsible for hanging the exhibition?
7. Who is responsible for the design, printing, and mailing of announcements and/or invitations?
8. Who is responsible for listing notices, press releases, and other publicity?
9. Who is responsible for any special security arrangements?
10. Who bears the risk of loss by fire, theft, or vandalism?
11. Will there be sales of the art from the exhibition space?
12. Who will fix the sales price?
13. Will the exhibition space receive a commission on sales?
14. If there is a commission, what is the % and when is it paid?
15. If the exhibition space collects the purchase price, when is it paid to the artist?

16. If an assignment results from the exhibition, is the exhibition space entitled to a commission?
17. Will there be an opening?
18. Who will pay for the costs of the opening?
19. Will there be newspaper and/or magazine advertising?
20. If there is to be advertising, who will pay for it?
21. Will there be an exhibition catalog?
22. If there is to be a catalog, who will pay for it?
23. Who will have title to the art while in the exhibition space?
24. Is either party responsible for any payment to the other?
25. Will there be post-exhibition representation?
26. What will be the terms and conditions of post-exhibition representation?
27. If a dispute arises, how will it be resolved?

The answer to each of the questions may stimulate a more detailed question, but if you and your exhibition space have agreed on the answers to the primary questions, you will have paved the way for a successful exhibition experience.

The Exhibition Space Agreement

There is no universally accepted or standard form of agreement between artists and exhibition spaces. There are forms proposed by various groups. Depending on whether a suggested form was written by an artist's organization or a trade association of galleries, there is usually an inherent bias in favor of the membership of the originating group.

Even if the form is devoid of bias, there may be a perception of bias on the part of one who is not a member of the originating group. The result is a reluctance on the part of an exhibition space to accept an artist's form and a reluctance on the part of artists to rely on the space's form of agreement. Several publications which contain such forms of agreements are listed in the bibliography.

The model form of agreement was drafted with the concept in mind that it should never be assumed that the photographer "always does x" and the exhibition space "always does "y." The model agreement requires every question raised in the preceding text to be answered each time the form is used.

Since the model agreement takes no position on whether, as a matter of course, any item is the responsibility or obligation of either party, it is devoid of inherent bias.

Negotiation may result in a final agreement which is more favorable to one party, but the starting point of the model agreement is neutral.

The model agreement assumes the art form is a print capable of being hung on the walls. It requires appropriate changes for holograms or other photographic art which occupies square feet of floor space, as opposed to linear feet of wall space, and which may require, for example, pedestals as opposed to frames. Aside from those types of modification the form may be used regardless of the structural nature of your photography.

The phrase "exhibition space" was chosen as being broad enough to encompass a gallery, museum, co-op, library, office building lobby, or enclosed mall.

The model agreement contemplates the possibility of representation by the exhibition space subsequent to the exhibit but was not designed to cover all the contingencies inherent in a long-term arrangement. It therefore does not deal with such questions as exclusivity, consignment of art to other dealers, or frequency of future exhibits. Suggested provisions may be found in the books listed in the bibliography.

While an agreement drafted by counsel, after negotiations with the exhibition space, may be the best of all possible agreements, the realities of life and the hourly rates of competent counsel make custom agreements the exception rather than the rule.

The fact that a model agreement is set forth for your use is not meant to imply that you should not use counsel or that it is preferable to one that might be drafted by your counsel. The model agreement was drafted and is reprinted in this volume because of a strong opinion that the use of the model agreement is preferable to having no written agreement.

In the model agreement, brackets, [], require that designated information be inserted or that a choice be made by placing an X mark in the appropriate bracket. An effort has been made to write the agreement in language comprehensible to those who do not have a law degree.

Model Form of Photographer–Exhibition Space Agreement

The Parties to this Agreement are [name of photographer] who resides at [address of photographer] (the "Photographer") and [name of exhibition space] located at [address of exhibition space] (the "Exhibition Space").

1. (a) The Photographer will exhibit at the Exhibition Space between [date] and [date], inclusive.

(b) The exhibit will be a solo [] group [] exhibition.

(c) Photographer will exhibit [number of pieces] occupying no less than _____ linear feet on the walls of the exhibition space. (If specific works are to be exhibited, they may be identified here or in an attached schedule.) The Photographer's medium is _____ . The work to be on display is "the Art."

2. (a) The Art will be delivered to the Exhibition Space by the Photographer at the expense of Photographer [] Exhibition Space [] (Note: Here and in any "payment provision" it may be agreed that instead of one party paying all of the expense relating to the provision that the expense be split in any percentage) between [date] and [date] during the normal business hours of the Exhibition Space.

(b) Unsold Art will be removed from the Exhibition Space between [date] and [date] during the normal business hours of the Exhibition Space at the expense of Photographer [] Exhibition Space [].

(c) If required, the Art will be framed by Photographer [] Exhibition Space [].

(d) The Art will be hung by Photographer [] Exhibition Space [] with final approval being the right of the Photographer [] Exhibition Space [].

(e) Lighting the exhibit will be the responsibility of Photographer [] Exhibition Space [].

(f) The following special security arrangements have been agreed upon: _____

and will be paid for by Photographer [] Exhibition Space [].

3. (a) There will be an opening of the exhibit: Yes [] No [].

(b) The opening will be on [date] from [hour] to [hour].

(c) Refreshments, if any, will be the responsibility of and paid for by Photographer [] Exhibition Space [].

4. (a) Invitations to the opening, if any, and the exhibit announcements shall be designed and printed at the expense of Photographer [] Exhibition Space []. The party not paying for the invitations shall have the right to approve copy and design: Yes [] No [].

(b) The party paying for the printing shall supply [number] invitations to the other party for their use.

(c) The invitations shall be sent by first class mail [] bulk rate [].

(d) Postage shall be paid by Photographer [] Exhibition Space [].

5. (a) The preparation and mailing of listing notices shall be the responsibility of Photographer [] Exhibition Space [].

(b) The preparation and mailing of press releases shall be the responsibility of Photographer [] Exhibition Space [].

(c) There will be newspaper and/or magazine advertising: Yes [] No [].

(d) If the answer to (c) is Yes the names of the publications, space sizes, and number of insertions agreed upon are as follows:

(e) The expense of newspaper and/or magazine advertising will be paid by Photographer [] Exhibition Space [].

(f) There will be an exhibition catalog: Yes [] No [].

(g) The responsibility for the preparation of the catalog is that of Photographer [] Exhibition Space [].

(h) The cost of type, half tones, color separations, design, and printing shall be paid by Photographer [] Exhibition Space [].

6. Title to the Art while on the premises of the Exhibition Space shall remain in the Photographer: Yes [] No [].

7. (a) Risk of loss of the Art while at the Exhibition Space, for any reason, including but not limited to vandalism, fire, or theft, shall be that of the Photographer [] Exhibition Space [].

(b) Art will be insured while at the Exhibition Space: Yes [] No [].

(c) If the Art is to be insured it shall be insured under an all risk policy in the amount of $_____ .

(d) The premium for insurance, if any, shall be paid by Photgrapher [] Exhibition Space [].

8. (a) The Art shall be offered for sale by the Exhibition Space: Yes [] No [].

(b) The Exhibition Space will receive a commission on the sale of the Art: Yes [] No []. The commission payable, if any, shall be _____ %.

(c) If there are to be sales of the Art the sales price of each work shall be fixed by Photographer [] Exhibition Space [] mutual agreement between Photographer and Exhibition Space [].

(d) The party collecting the sales prices, if any, shall pay the portion of the sales price which it is not entitled to retain to the other party within [number] days of receipt of the payment.

(e) If Photographer receives a special commission for work to be created as a result of the exhibition will the Exhibition Space be entitled to a percentage of the fee? Yes [] No []. If the answer is Yes, the Exhibition Space shall receive _____ % payable within [number] days after receipt by Photographer of payment.

9. (a) Is Exhibition Space guaranteeing any minimum payment or sales to Photographer? Yes [] No []. If the answer is Yes, the amount payable is $ _____ and shall be paid on or before [date].

(b) Is the Photographer obligated to pay for use of the Exhibition Space? Yes [] No []. If the answer is Yes, the Photographer shall pay $ _____ to the Exhibition Space on or before [date].

10. (a) Subsequent to the exhibition will the Exhibition Space act as a dealer for the Photographer? Yes [] No [].

(b) If the answer is Yes, will the sales commission remain the same as that payable during the exhibition? Yes [] No []. If the answer is No, the new commission will be _____% and will be paid on sales occurring subsequent to the [number] day after the close of the exhibition.

(c) If there are to be sales of the Art, the sales price of each work shall be fixed by Photographer [] Exhibition Space [] mutual agreement between Photographer and Exhibition Space [].

(d) The party collecting the sales price, if any, shall pay the portion of the sales price which it is not entitled to retain to the other party within [number] days of receipt of the payment.

(e) Post-exhibition representation, if any, shall continue for a period of [number] months from the end of the exhibition.

11. (a) Photographer hereby grants to Exhibition Space the right to use his/her name, likeness, and reproductions of the Art in advertising and promotion.

(b) Photographer represents to Exhibition Space that (i) the Art is original work and that the copyright is owned by Photographer, (ii) any required model releases and/or permissions to use the incorporated work of third parties have been obtained in writing, and written copies are in the possession of Photographer, (iii) the Art is owned by Photographer free and clear of all liens and encumbrances, and (iv) if the Art is a multiple, requiring a disclosure document under the law of the state in which the Exhibition Space is located, Photographer has supplied complete and accurate information to the Exhibition Space, sufficient for compliance with such disclosure law.

(c) Exhibition Space agrees not to loan, rent, or subconsign the Art without the prior written consent of Photographer.

(d) Exhibition Space agrees that it will not permit the Art to be copied, photographed, or reproduced except as permitted in this Agreement, without Photographer's prior written consent.

(e) Exhibition Space agrees that included in each bill of sale will be the following legend: "All rights to reproduce the work(s) of art conveyed hereunder are retained by the artist."

12. This instrument contains the entire Agreement of the Parties relating to the subject matter hereof, and the Parties have made no agreements,

representations or warranties relating to the subject matter of this Agreement which are not set forth herein. No modification of this Agreement shall be valid unless made in writing and signed by the Parties hereto.

13. This Agreement shall be deemed to have been made under, and shall be governed by, the laws of the state where the Exhibition Space is physically located.

14. Any controversy or claim arising out of or relating to this Agreement, or the breach thereof, shall be settled by arbitration in accordance with the Commercial Arbitration Rules of the American Arbitration Association in the City of _____ , State of _____ , and judgment upon the award rendered by the Arbitrator(s) may be entered in any Court having jurisdiction thereof.

Dated: _____

Photographer

(Exhibition Space)

by _____
(Name—title)

<><><>

Miscellaneous Comments

Paragraphs 11 through 14 of the Model Agreement contain provisions which lawyers refer to as boilerplate. They cover points over which there should be no real dispute. You are entitled to certain protections from acts

of the exhibition space, and the exhibition space is entitled to certain protections.

Paragraph 14 may be, to some persons, a controversial clause. It requires arbitration, as opposed to court proceedings, in the event of a dispute, difference, or controversy between you and the exhibition space. It was included because lawsuits are expensive and time consuming. Often the legal fees are disproportionate to the amount at issue or point in dispute.

Arbitration can proceed without attorneys and is usually speedier and less formal than court proceedings. Arbitration is not a perfect means of resolving controversy, but neither is litigation. Considering the magnitude of the type of dispute, difference, or controversy which may arise in connection with an exhibition, and the resources of most artists and exhibition spaces, arbitration is an attractive alternative to court proceedings.

Commissions

One frequently asked question is, "What is the normal commission charged by exhibition spaces?" There is no normal or standard commission. Commissions can range from as high as 60% to as little as 10%. The commission rate is based on the nature of the exhibition space, the selling price of the art, and what services the exhibition space supplies to you.

The majority of commercial spaces have fixed percentages from which they do not deviate. The commissions of commercial galleries tend to cluster between 35% and 50%. If your work sells well, you may be able to negotiate a lower percentage at agreement renewal time.

Long-Term Post-Exhibition Representation

The model form of agreement was drafted as a document for use in connection with an exhibition. If the exhibition space is a commercial gallery and there will be long-term post-exhibition representation, there are other questions to be settled.

They include (i) exclusive representation within a particular geograhpic area, (ii) whether the agreement is assignable to a subsequent owner of the gallery, (iii) the frequency of accountings for sales, (iv) consigned art and the rights of creditors of the gallery in states where there is no artist protective legislation, (v) commissions on studio sales, (vi) profits on resale, and (vii) future exhibitions.

Each of these items requires the addition of one or more paragraphs to the agreement. While provisions for both an exhibition and post-exhibition representation can be contained in the same document, I elected to provide a model agreement drafted primarily to sales resulting from the exhibition. That election was made because many of the exhibitions resulting from following this guide will take place at not-for-profit and alternative exhibition spaces.

The bibliography lists several form books containing agreements for use by artists. Several of them include provisions required in a long-term post-exhibition representation agreement.

The model form has been reprinted in Appendix D without the explanatory notes in the brackets. You are hereby granted permission to make up to five photocopies of the model agreement for use in connection with your exhibit. If you are puzzled as to what information is inserted within the brackets, refer back to this chapter.

Summary

There are not enough fingers in a handshake to answer all the questions that must be asked in connection with your exhibition.

A written agreement is not a sign of distrust; it is a mark of intelligence!

Your Budget

The subtitle of this book, "There Is More To An Exhibit Than Meets The Eye," was selected to alert you to the fact that an exhibition involves much more than the placement of your prints on the walls of the exhibition space.

The budget checklist and the table of contents reinforce one another to alert you to all of the elements that combine to make your exhibition successful.

This discussion of budget is not meant to awe you or to discourage you. It is designed to remind you of the obvious and alert you to the less obvious expenses.

All of the budget items are rarely at the expense of the photographer. The exhibition space often assumes many of the basic and larger expenses. Where, however, you choose an alternative space, such as the lobby of an office building, you may find that all that is being supplied to you are the walls.

In your discussions with representatives of exhibition spaces you must be realistic concerning the resources available to you and to the exhibition space. A well-endowed museum or bank gallery may absorb every expense including a lavish opening buffet. Others will require you to pay for all or a portion of the expense. While a commercial gallery may offer more to an established artist, a co-op gallery will treat every artist equally. Before agreeing to exhibit, ascertain your obligations and what they represent in terms of dollars.

If you ask all of the questions listed in **YOUR AGREEMENTS WITH EXHIBITION SPACES** you will know the magnitude of your dollar obligations.

The Budget Checklist commences with the expenses incurred in contacting and visiting exhibition spaces. They are included because contacts and visiting are real expenses of an exhibition.

The checklist is designed to be as complete as possible. It will be rare that any one exhibit will involve an expense for every enumerated item. You should, however, be aware of the possibility of every expense and agree with the exhibition space on whose pocket will provide the money.

Exhibition Budget Checklist

1. Contacting and Visiting Exhibition Spaces
 a. phone charges
 b. postage required to mail and obtain return of "portfolio"
 c. transportation costs
 d. food and lodging for out-of-town trips
2. Preparing Your Art for Your Exhibition
 a. materials for additional pieces required for the exhibition
 b. mounting and framing
 c. lighting fixtures if space is inadequately lit
3. Delivery and Return of Your Art
 a. delivery charges or rental of van
 b. labor charges if you are unable to handle your art without help
4. Legal Advice in Connection with Agreement with Exhibition Space
5. Postage
 a. listing notices
 b. press releases and press kits
 c. invitations and announcements

6. Printing

 a. invitations and announcements

 b. exhibition brochure or catalog

 c. photocopy costs for listing notices and press releases

7. Publicity and Public Relations

 expenses other than postage and photocopy costs—e.g., press person, prints and color separations

8. Advertising

 a. ad preparation

 b. media

9. Insurance

 a. on art while at exibition space

 b. on art while in transit

 b. liability insurance if exhibition space isn't insured

10. Special Security Arrangements

11. Opening Reception

 a. refreshments

 b. labor charges for servers, cleanup, and building personnel

12. Exhibition Space Fee

 a. co-op charges

 b. space rental at subsidy gallery

13. Out Of Town Exhibition Costs

 travel, food and lodging

 In addition to the listed items you may find that circumstances unique to your exhibition or art require additional budget lines.

Who Pays?

The question of who pays for which budget items is almost always answered by the type of exhibition space and its economic well-being.

A not-for-profit space that is well-endowed, or has a government or corporate exhibition subsidy, may assume all expenses. Other not-for-profit spaces may be able to offer little more than their walls and assistance in hanging the exhibit. Cooperative galleries often require, in addition to payment of cooperative dues, payment of an exhibition fee.

Commercial galleries tend to have policies to which they adhere. They differ widely. Some galleries always pay for an opening while others refuse to permit openings regardless of the artist's offer to pay expenses.

There are no absolute rules for what is fair or usual. There are, however, budget items which, by custom, are generally assumed by the exhibition space and budget items which, by custom, are generally assumed by the artist.

The only absolute rule is to ask and agree . . . don't assume anything!

The following discussion is meant to give you an overview. It is not the Ten Commandments of budget allocation.

Contacting and Visiting Exhibition Spaces

The expense of contacting and visiting exhibition spaces is that of the artist. Similarly, the expense of sending samples of work and return postage

is that of the artist. The one exception is when you are first approached by the exhibition space. In that event, the cost of an out-of-town trip may be paid by the exhibition space.

Preparing Your Art for Your Exhibit

Normally the cost of material for producing your art is borne by you. When you have finished your preliminary planning, you should have a sufficient oeuvre for an exhibition. If the exhibition space decides that the offer of an exhibition is conditional on your producing more work of a particular style or subject matter, you can raise the issue of their paying for materials. If it is a commercial gallery, they may offer to pay provided they can recoup from sales. A not-for-profit space may have a grant for the exhibition from which you can receive reimbursement for materials.

The mounting of prints is normally done by the photographer prior to delivery of the work to the exhibition space. Framing is normally done on the premises of the exhibition space. If the exhibition space is an alternative space, there may be no facilities for framing on premises, and you may have to deliver framed art. The expense of framing, in most exhibition spaces, is borne by the space. They usually have frames and staff experienced in framing.

Exhibition spaces may or may not have lighting acceptable to you. If you require special lighting, you may have to be prepared to pay for additional or new fixtures. In alternative spaces, such as the lobby of a building, or a university student center, you may find, not only inadequate lighting, but almost no economical way of remedying the situation. In an exhibition space with

track lighting, you can add fixtures or change reflectors and bulbs. In an alternative space you may find that the walls lack outlets and the ceiling fixtures are recessed. Moreover, the management of the alternative space may not be enthusiastic about your doing anything other than hanging your art.

Delivery and Return of Your Art

The delivery and return of your art can, in some instances, involve little more than loading up a car or station wagon and driving for 30 minutes. In other instances it may involve packing framed work for shipment to another state. If your work consists of large photographic sculptures or 40" x 60" box mounted prints, transportation even from one end of the block to the other presents major logistic problems accompanied by comparatively large numbers on the budget line. If the locations of your work space and the gallery are not at street level, make certain that you can get your art out of your space and into the exhibition space. Small elevators and narrow stairways are the bane of large works of art.

The majority of exhibition spaces require you to both deliver and remove unsold art. Since space is limited in most urban galleries, you will be asked to remove unsold work that is not being retained for future sale, within a few days of the exhibition close.

If you require a trucker to transport your art, it will be expensive, particularly when each work of art is large and the shipping distances are long. If crating is required, you may find that the budget line for delivery and return of your art will be larger than any other.

Don't be overly optimistic. Calculate the cost of delivery and return. Few exhibitions are complete sellouts.

Legal Advice

In the context of most exhibitions, legal advice is a luxury. There is no question that you should have a written agreement with your exhibition space, but most business contracts are signed without the assistance of counsel. If you don't understand the agreement or have a special problem, you may need counsel. Although the model agreement contained in **YOUR AGREE-MENTS WITH EXHIBITION SPACES** was drafted by an attorney, it may not meet your special needs. Nevertheless it is a good starting point, and you may find that you can proceed without advice tailored to your exhibit. As in most transactions, each party pays for its own legal advice.

Postage

Postage can be a significant budget item, particularly if you or the exhibition space has a large mailing list. The general custom is that commercial galleries and not-for-profit exhibition spaces pay the postage for the mailing of announcements and invitations to persons on their list. They may even permit you to submit several hundred names to be added to the list.

Do not fall into the trap of agreeing to use bulk mail unless abso-lutely necessary. Bulk mail is substantially less expensive than first class mail but the old adage that you get what you pay for applies. The delivery time for bulk mail can range from two days to two months. If you use bulk mail, mail four to six weeks before the event.

Always use first class postage on all mail to media and to those whom you particularly want at the opening.

Listing notices and press releases are not sent out in such numbers as

to make the postage a significant amount. Press kits, however, depending on the amount of material contained, may cost from 54¢ to $2.40 per kit, to mail.

Printing

The cost of invitations and announcements is always a significant number. The exhibition space customarily pays for the printing or fixes a dollar number which they agree to pay. Any excess is paid by the artist. You may desire to order extra quantities for your use or to use color when the exhibition space's budget allows only for black and white. Extra quantities of announcements printed in color may be useful to you in connection with obtaining future exhibitions.

Arrange to have part of the press run omit the information specific to the particular exhibit. You can use the extra quantity for a subsequent exhibit and either imprint the new information or use the image portion with a separate second sheet or card.

Few exhibitions are accompanied by a catalog. Catalogs are usually printed in connection with museum exhibitions or gallery exhibitions by well-established artists. In both those instances it is the exhibition space that pays the bill. A catalog is a small illustrated book and in some instances may be distributed through bookstores. Catalog preparation is time-consuming for the personnel of the exhibition space and the artist.

While it is certainly a plus for the artist, and can be used to stimulate future exhibits, a catalog is not an essential element. If you desire to have an exhibition catalog, you will probably write the checks.

If you feel a catalog is critical to your exhibition and you are footing the bill, consider one of the printers mentioned in **Appendix A**. Their range of standard products includes brochures and commercial catalogs which can be designed as exhibition catalogs.

Photocopy Costs for Listing Notices and Press Releases

Exhibition spaces usually, but not always, have their own mailing lists for listing notices and press releases. Often they have the personnel to handle both the preparation and the mailing.

Photocopy costs for listing notices and press releases are normally borne by the exhibition space if they are handling the preparation and mailing. They are not a large budget item, and if you are doing your own listing notices and press releases, you will probably absorb the expense.

Publicity and Public Relations

If the exhibition space uses outside public relations persons, they will pay the fee. If you hire a public relations person, you will pay the fee. Even if the public relations work is done in-house, there may be an expense item for press prints or color separations. Press prints are customarily paid for by the party sending out the press releases. Color separations are reserved for publications that are doing reviews or stories about the exhibition. The more affluent the gallery or not-for-profit institution, the more likely they will agree to pay for the separations. If they will not pay, you may consider separations a good investment since they can be reused. The offer of color separations may result in a story or review if the publication uses color, but is on a tight budget.

If you are absorbing the cost of public relations, whether you do it yourself or have it done by a professional, the postage for press packets, as opposed to press releases, will have to be figured into your budget. While the cost of mailing a press release will not be greater than the cost of a postage stamp sufficient for 1 oz., the addition of a 9"x12" envelope, a presentation folder, a press print, and cardboard to prevent damage to the print may easily escalate postage to above $1. per press packet.

Use press prints judiciously. Don't bother to include them with releases sent to publications that don't use illustrations or never illustrate stories on exhibitions. If your art is dramatically different and your budget permits, you may want to include press prints with every press release just to catch the attention of the editor.

Remember that the post office takes great pleasure in ignoring the notice on envelopes that states "PHOTOGRAPHS—DO NOT BEND." Use at least one piece of cardboard, larger than the print, to protect the press packet.

Interestingly, it is the not-for-profit spaces that often offer and supply the most elaborate and effective public relations. Their own staff or outside firms are professional in their approach and have good media contacts.

Media favor the coverage of not-for-profit institution activities, and the identical exhibit may find itself with little more than a listing if it is at a commercial gallery, but there may be a story if it is at a not-for-profit space.

Advertising

Advertising is the cause of more debate than any other budget item. One of the reasons is that the effectiveness of space ads in increasing exhibition

attendance and/or sales is questionable. Regular advertisements in art magazines and in the art sections of local newspapers may establish a visible presence for the exhibition space, but their effect on a single exhibition of an emerging artist may be minimal. If the exhibition space always advertises its exhibitions you probably will have no problem with the question of who pays. If the exhibition space does not advertise, and most do not, you may have to pay for the ad. The question of whether space advertising is cost-effective is always a subject of debate. Space advertising is not an item over which blood should be spilled. If seeing your name in an advertisement is meaningful to you, and the exhibition space will not pay for space ads, you will have to pay the bill.

Most commercial galleries will pay for the listing in the regional edition of *Gallery Guide* or similar publications. Those paid listings do increase attendance at exhibitions. Newspaper and magazine listings are free, but in major metropolitan areas out-of-town visitors often rely on *Gallery Guide.*

Few exhibition spaces use radio or TV advertising. It is expensive and reaches too broad a target. Occasionally there will be a special exhibition that can be brought to the attention of the listeners of a particular program. In general you will find that not many exhibition spaces will agree to pay for radio or TV time.

One California gallery had enormous success with time purchased just after a well-known network TV news documentary. The local affiliate of the network had a low advertising rate, and the demographics of its air audience was on target for the work carried by the gallery. It is rare to find that combination of affordable cost and good demographics.

Some radio stations have free announcements of cultural events. You may be able to obtain a listing on such programs, particularly if your exhibit is at a not-for-profit space.

Insurance

If the exhibition space has sufficient insurance coverage there is no question of who pays for insurance. The question of who pays arises when the exhibition space has no insurance or inadequate insurance. If you already have sufficient fire, theft, and vandalism insurance, you may be able to have a rider attached to your policy covering your work while in transit and while on exhibit. The cost should be nominal. If a new policy has to be written, it will be more expensive, and you will probably have to pay the premium.

Special Security Arrangements

Special security arrangements are rarely necessary in established exhibition spaces. If, however, you are using an alternative space, you may require a special guard or methods of closing off the area during periods when the exhibition is not open to the public. If you have initiated the exhibition, you will probably end up paying the cost. Make certain that those costs do not exceed the value of what you have on display. If your medium is a multiple, you may find that special security is not important since identical copies of your art exist.

Opening Reception

The opening reception does attract people who would not otherwise see your exhibit.

Few sales, however, are made at the opening. If sales are recorded at the opening it is usually because they have been orchestrated by the gallery or are the result of relatives and friends demonstrating their belief in your work.

The primary function of opening receptions is to delineate the point in time when the show must be finally hung. It is amazing how much progress is made in the hours before a hundred people are expected to walk through the doors of the exhibition space.

A secondary function of an opening is to have a party celebrating the exhibition.

Most, but not all, exhibition spaces will pay for the costs of an opening reception and supply wine. If you desire a more elaborate menu you will probably have to pay. Unless the opening attendance is expected to run more than 100, the cost of wine and cheese will be modest.

The budget line for an opening can be a major expense if you desire champagne, hot food, or hard liquor. None of those items is required for a successful opening. In fact, if your exhibition space has a carpeted floor, they will probably be quite happy to see your food service limited to a hard cheese. Hot food, sour cream dips, and soft cheese are not favorite items with exhibition space personnel charged with cleanup. Champagne is festive but expensive. Dry white wine is very much an "in drink." Hard liquor is both expensive and prone to induce conduct which is inappropriate for an opening.

If the opening is not during the normal business day, there may be an expense to keep the exhibition space open. Building and exhibition space personnel may have to be paid overtime. If the opening is held during warm

weather and the space does not have its own air conditioning system, it may have to pay a fee to keep central air conditioning running during evening hours.

Bartenders, waiters, and cleanup staff may also be required. Generally the exhibition space will take care of those items if they are paying for the exhibition.

Exhibition Space Rental Fee

If you are exhibiting at a co-op or an alternative space, you may have to pay a fixed exhibition fee. Some galleries also require the payment of fees on the theory that if your work does not sell, they will at least have rent money. Although payment is the exception, you may find that your reason(s) for having an exhibition justify paying for an exhibition space.

Travel, Food and Lodging

If your exhibition is at an out-of-town space, you may incur travel expenses. Depending on the distance from your home, there may be expenses for food and lodging. Unless you have been invited by the exhibition space you will find that these items are your expense.

Summary

The purpose of this chapter on budgets is not to intimidate you. Exhibitions always are accompanied by expenses. In many instances the

exhibition space will bear most, if not all, of the costs. You should be aware, however, that few exhibition spaces have unlimited budgets.

You should now have a good idea of all the expenses that may arise in connection with an exhibit.

Some are clearly optional, but many are necessary. You must send out listing notices and announcements. You can omit the opening, but someone must deliver your art and return it to your studio or home.

You can eliminate some expenses and minimize others. You can't eliminate all the expenses.

Your Exhibition Announcements and Invitations

Your exhibition announcement is analogous to the display window of an expensive shop. It must convey a message more subtle and complex than "someone is having an art exhibit." The announcement must stimulate the response . . . "Yes, I want to see that exhibit."

In terms of information, the announcement must set forth information identical to that on the listing notice: (1) the name of the exhibition space, (2) the address of the exhibition space, (3) the days/hours the space is open, (4) the name of the artist, (5) the medium, (6) the name of the exhibition (if there is one), (7) the opening and closing dates, (8) a phone number for the exhibition space or person from whom information can be obtained. In addition, you should add a copyright notice to protect your rights in the art which is reproduced on the announcement.

An invitation is an announcement with additional information relating to an opening. The additional information is the date and hours of the opening. That additional information can be part of the announcement or, if everyone on the mailing list is not to be invited to the opening, on a separate piece of paper. By using a separate sheet of paper or card, you can convey the idea that the invitation to the opening is only for special people. Close friends, family, media persons and present and potential collectors of your work should comprise the "must list" for the opening.

At no point in planning an exhibition is there a greater opportunity to make expensive mistakes than at the time you decide on the form of announcement. Even when you have made the correct decision, your failure

to include the necessary elements of required information can derogate from the effectiveness of the announcement and cause the waste of the hundreds of dollars spent on printing and postage.

It is a foregone conclusion that your friends and relatives will probably visit your exhibition space. You could probably send out a mimeographed announcement, and they would come!

But what about media people, business associates, and collectors? The first rule to remember is, "The cost of postage is the same whether your announcement is in four colors or reproduced on a mimeograph machine." Postage is calculated on weight and class of mailing, not the quality of the printing and design. The announcement is the first representation of your work that people will see. Even if your budget allows for nothing more than a bare bones announcement, it should be typeset and printed on a good-quality paper or card stock.

The second rule is, "If possible, avoid mailing announcements and invitations by other than first class mail." Bulk rate mail, both commercial and not-for-profit, saves money, but the message may arrive long after the event! If you must mail by bulk rate, make certain the post office has the material at least five weeks before the event. Never, under any circumstances, use bulk mail for invitations sent to media or those you truly want to attend your opening. The risk is too great that they will not receive it prior to the event.

Between the mailing list of the exhibition space and your own list, there may be between 2,500 and 10,000 announcements to be mailed. Assuming you plan to use an invitation enclosed in an envelope, the first class postage, as of the publication date of this book, will be $220 per thousand or $550 for 2,500.

Shouldn't you budget an equal amount on the actual announcement? The announcement represents the exhibition space, you, and, most important, your art. Should the king's herald be dressed in jeans? If your art is in color, why shouldn't the announcement be in color?

By planning ahead, a four-color announcement can cost less than $300 for 3,000. That price includes a color separation!

Appendix A, "Sources," contains a list of printers who produce four-color work at economical rates. Write or call for their current catalogs and samples as soon as you start thinking about an exhibition. When you get the catalogs, you can check the prices against those of local printers.

Selection of the work to be reproduced on your announcement should take into consideration the printing process by which the invitation is to be reproduced, whether the work is representative of the exhibition, and whether the work is likely to entice the recipient into seeing the whole exhibition.

Types of Announcements and Invitations

Since the difference between an announcement and an invitation is related solely to the nature of the information contained in the text, the principles relating to form and method of reproduction are identical.

Unless your budget is unlimited, and you desire to print separate invitations and announcements, your planning should contemplate use of a format which will allow you to print an announcement and, by adding the

opening information to a portion of the announcements, to use the announcement as an invitation.

There are numerous ways to add opening information. One method is to print the announcement information allowing room for the printer to slug in the additional information on a portion of the press run. For example, the invitation information may be as simple as a line of type reading, "Opening Reception – Tuesday – October 1 – 6-8 pm."

Depending on the printing process and the equipment used, it may be possible to add or in some instances to eliminate the information during the press run. With some equipment it may be necessary to run the announcement through the press a second time. Ask your printer for advice on the most economical procedure. Because of differences in the printers' equipment, the answer and costs may vary from printer to printer.

A second commonly used method of adding opening information is to enclose a separate card or sheet with the announcement.

If your opening invitation list isn't large, a neatly handwritten note on or with the announcement will suffice.

The least desirable method is a rubber stamp on an otherwise attractive announcement.

One method that isn't recommended is to print the opening invitation on all the announcements. Only those addressed to opening invitees are mailed prior to the opening. The remainder are dropped into the mail the day of the opening. Those who receive the mailing "late" feel like second-class citizens or believe that you are not properly organized. You also run the risk of losing attendance because the announcements arrive late.

Color v. Black and White

In the folklore of the art world it is generally believed that the cost of color announcements is dramatically higher than the cost of black and white.

While it is true that color is generally more expensive, it is not necessarily dramatically higher. If your work is in color you must, at the minimum, consider color and price it in relation to black and white.

The cost of the same print job can vary as much as 300% from printer to printer and even the same printer will quote a substantial premium for a last-minute rush order.

The third rule in connection with an announcement, invitation, brochure, catalog, or poster is, "Start early and price the job with at least three different printers." You may be surprised to find that your local printer who did an excellent job on your letterhead is more expensive than a large national printer.

After getting catalogs from the sources listed in **Appendix A** and quotes from local printers, you can make an intelligent decision. Request samples from all printers. They will give you ideas and an opportunity to see the quality of their work. We have been surprised to receive poorly printed catalogs and samples from printers. You can be certain we did not order from those printers.

Certain elements of an announcement remain relatively fixed. The cost of layout, type, paper or card stock, and press time are all elements of any print job, whether in color or black and white. A good-quality textured card stock for a black and white job may cost more than the coated stock

required for color. Some of the sources listed in **Appendix A** include the costs of both color separations and typesetting in the price.

If the printer is not quoting a price which includes the type and a mechanical, you must obtain at least three quotations on those elements. You may be surprised by the range in prices.

Press time is a component of cost. Press time is determined by the equipment. A high-speed press may run 3,000 four-color announcements faster than a sheet-fed press can print 3,000 in one color.

A large printer, specializing in color, may offer a choice of only one or two paper stocks. But the price may compensate for the limited choices. The stock is purchased in large quantities at prices that smaller printers cannot match.

Even if you require only 1,000 announcements, it may pay to print a larger quantity. If, for example, the minimum quantity is 3,000, you can leave the specifics of the particular exhibition off 2,000. You will then have an inventory of 2,000 color announcements for future use. They can be imprinted, as required, with information for future exhibitions or used in other ways to promote your work.

The incremental cost of the copies, for which you have no immediate use, will be surprisingly low.

One technical term you will learn is "gang printing." What that term means is that your job will be run at the same time as other jobs on large rolls of paper or card stock. The jobs are cut to size after passage through the press. While there may be some sacrifice of exact color reproduction, our own experience is that a job run alone is not necessarily better but is always

more expensive. All but the most expensive color art books have their pages gang run!

If you submit a good-quality chrome or reflective art to the person who makes the color separations you should obtain results that will please you.

A Low-Cost Alternative to Four-Color Process

If you require a relatively small number of invitations, you may obtain a color announcement at a modest cost.

Consider using an announcement that is photographically reproduced. In short runs, photographically reproduced invitations are economical. They also can be used when time is a factor.

What we are suggesting is an announcement or invitation that resembles a holiday greeting card reproduced on color print paper.

Your art replaces the traditional family picture, and the season's greeting is replaced by the information relating to your exhibit.

Most commercial photography labs can do the job, but a lab specializing in that type of work will have automatic printers and will offer the best prices. In most instances, you will have to supply the lab with a mechanical for the message portion of the announcement.

As opposed to the chrome that printers need in order to make color separations, the lab requires a color negative. One can be made from a chrome or from your art, but there is usually an extra charge for that service.

The least expensive source we have found for this type of announcement is listed in **Appendix A**. Write for their price list and check it against

labs in your area. The current price for 100 4"x 5" color announcements produced photographically is $50.

Color announcements can also be produced by using both printing and photography. This hybrid consists of a printed invitation with a photographically reproduced color print affixed to the announcement.

Photographic reproductions of your work may also be used, even if you go to four-color process for the small quantities you may need early in your planning, in connection with reviews and public relations.

The fourth rule is, "Never submit original work for the printer to use." You should have a chrome, negative, or print made of your work, depending on the reproduction process to be used. Refer to **YOUR CONTACTS WITH EXHIBITION SPACES** on the perils of photographing your work without understanding the special techniques required for the photographing of art.

Attractive Invitations Without Color

While color may be preferable to portray art that is not monochromatic, attractive invitations can be designed and printed using colored ink or stock.

One fact to remember is that the cost of special stock may double or triple the cost of a job. Instead of specifying special stock, find out what paper and card stock your printer has in his inventory. What he normally buys in quantity will end up costing you less. He may even have a quantity of expensive stock left over from another job that can be yours at an attractive price.

In order to avoid extra first class postage charges, it is important to be certain that the total weight of everything going into your announcement envelope and the envelope itself does not weigh more than 1 oz.

Size

Graphic designers and art directors love to specify sizes of announcements and invitations that stand out from the crowd of ordinary mail. There are two problems with nonstandard sizes. The first consideration is your budget ...but more about that later.

The second consideration is that mailboxes, particularly in urban areas, are small. A beautifully printed announcement that is folded by a mail carrier in order to fit into a narrow apartment building mailbox loses most of its aesthetic clout.

If your budget is limited, neither you nor your designer should specify an announcement size that will not fit into a standard envelope. The minute you move away from standard sizes, you end up with incremental costs. A nonstandard-size paper or card specification may increase costs because of extra charges for cutting or trimming.

The Time Factor

The cost of printing is often directly related to the time you have allotted to the printer. Designing your announcement should commence immediately after reaching an agreement on the exhibition dates and determining the budget allocated for printing.

While it is not advisable to mail the invitations three months before your opening, it is not too early to go to the printer at that time.

You may be pleasantly surprised to receive your job in ten days, but it pays to allow six weeks for a four-color print run. The time frame may be even greater if you want to see press proof or an alternative process proof.

If you are mailing by bulk mail (the special not-for-profit organization bulk rate gets the same slow service as commercial bulk rate mail), you must allow four to six weeks for the post office to do its job.

Addressing and stamping, particularly if not done from a mailing list on a computer or on other automatic equipment, also require time.

The last rule is therefore…"It is never too early to order announcements and invitations!"

Your Publicity

Publicity is free media coverage. If you pay the media for coverage it is considered advertising.

One of the reasons for commencing plans for an exhibition at the earliest possible time is to obtain maximum publicity. An early start does not guarantee publicity, but a late start will certainly limit the amount of publicity your exhibition will receive.

The reason for early planning has its basis in the concept of lead time. Lead time is the amount of time between a publication's editorial closing date and the date it is distributed to the public. The general rule of thumb is that the longer the time between publication dates, the longer the lead time. Thus a daily newspaper has a shorter lead time than a monthly magazine. Publications using color have a longer lead time than publications that do not use color. We will return to lead time later in this chapter.

Publicity can be broken down into several categories. The first and most elementary is the listing notice. The second is the press release designed to elicit a story, and the third is the pre-exhibition review. Reviews are covered in the next chapter.

If your exhibition is scheduled for a gallery or museum, much but possibly not all of the publicity will be undertaken by their staff. Nevertheless you should involve yourself in the process. It is not suggested, however, that you preempt their functions or interfere in a manner that alienates the staff. You may, however, be able to provide welcome assistance.

Regardless of who has the responsibility for publicity, you should read this chapter in order to understand what constitutes publicity and how it can help you and your exhibition.

The Listing Notice

The most elementary publicity is the notice which tells the reader of a publication that an exhibition of your work will be held. The listing reaches people you don't know and those who aren't on your mailing list. It reinforces your mailed announcement and invitation. In metropolitan centers the listing may even produce more viewers than your mailing!

A listing notice is a bare bones set of facts containing the following elements: (1) the name of the exhibition space, (2) the address of the exhibition space, (3) the days/hours the space is open, (4) the name of the artist, (5) the medium, (6) the name of the exhibition (if there is one), (7) the opening and closing dates, (8) a phone number for the exhibition space, or a person from whom information can be obtained.

Not all publications use all eight elements, but every listing notice should contain all eight.

The elements are self-explanatory, and all seem obvious. Nevertheless, each month, every listings editor receives listing notices which omit one or more key elements. Notices have been received without the dates of the exhibition, without the location of the gallery, and without the medium. The medium is important because some publications list exhibitions by medium. One example is *The New York Times,* which lists photography exhibitions separate and apart from all other exhibitions. Other publications, because of the composition

of their respective readerships, will list only certain types of exhibitions. Don't assume that the listings editor knows what medium you use.

The title of the exhibition is important for publications that have specialized readerships. You are more likely to have an exhibition of color prints of birds listed in a nature publication if the editor is made aware of the subject matter. Listings in specialized publications are often placed in a "Coming Events" or "Calendar" section or a column containing a variety of information about persons, places, and events. The bulletins, newsletters, and magazines of membership organizaions are often receptive to mention of an event in which one of their members is participating, even if not directly related to the organization's activities.

The listing notice should be sent to the listings editor at each publication. That person may be different from the person to whom a press release is sent. At the minimum, address each listing notice to the title: Listings Editor. If possible, use the name of the listings editor. That is preferable to the generic name "Listings Editor." Smaller publications may have only one person with the general title "Editor."

Newspapers, newsletters, and magazines carrying listings of art exhibitions usually, but not always, print every notice received. Some are selective. It is rare for a listings editor to call to ascertain missing information. Deficient and late listing notices end up in the wastebasket.

If you use the letterhead of the exhibition space, elements 1 through 3 and 8 may be preprinted. The remaining elements must be customized for each exhibition.

The following form of listing notice contains all the necessary facts. Make certain that your listing notice is complete and accurate.

Sample Form of Listing Notice

XYZ GALLERY

123 Argent Street

New Orleans, LA 70112

Ruth French, Director **(318) 666-9999**

To: (Name of Listings Editor) or The Listings Editor

Please list the following exhibition at our gallery:

 Photographer: Paul Atget

 Medium: Platinum Prints

 Exhibition dates: March 7, 1989 through April 8, 1989

 Exhibition title: Recent Urban Landscapes

 Gallery hours: Tuesday through Saturday — 10am to 5pm

The listing notice should be sent first to those publications with lead times of several months. If you send all the notices out with the earliest listing notice, you run the risk that they will be misplaced before they are used.

The first step is to compile a list of all publications that may list your exhibition. A good starting place is the media list maintained by the exhibition space (the ES List). You should add to the ES List publications that you know which carry listings.

To augment the ES List and your list, you should refer to at least

one directory that is updated annually. The *American Art Directory* has sections containing the names and addresses of art magazines and newspapers carrying art notes. The name of the critic for each newspaper is supplied. The ES List and your personal list should be augmented by additional names in those sections. Use the most recent edition in order to obtain the names of new publications, new addresses, and changes in assignments.

Specialized publications should also be considered for listing notices. You probably know some of the specialized publications in your field but you are certain to find new ones in *The Standard Periodical Directory,* which is organized by subject matter.

Your local municipal or university library should have copies of the *American Art Directory* and *The Standard Periodical Directory.*

The master list you assemble will not only serve as the mailing list for listing notices, but it also will be used as a press release mailing list.

I suggest that the list be assembled in a form which makes it possible to duplicate labels without retyping. Once a master list is assembled on either labels or a label master sheet, you can use a copying machine to make duplicate sets of labels. Most boxes of self-adhesive address labels come with a master sheet which provides the correct spacing.

If you have access to a personal computer or word processor, the list can be entered and either labels or individual envelopes printed.

Corrections to the master label list are made by placing a label with the new name or address over the incorrect label. Corrections, if you use a personal computer, are made by changing the data.

Let us return to the concept of lead time. Your exhibition space staff may already be armed with the information regarding the lead time required for the media on their list. As to the media you add or for which the exhibition space has no information you, or someone on your behalf, should sit down with the media list and call to ascertain the lead times. The question you ask is, "What is the closing date for the listings in the _____ issue?" You are going to spend a lot of time and effort on your exhibition. Don't economize on either phone calls or the time required to get out your publicity.

If you don't know the lead time for a particular publication, the following rules of thumb may be of help: (1) for monthly publications a lead time of 3-4 months; (2) for weekly publications a lead time of 3 weeks; (3) for daily publications a lead time of 1 week. These lead times are only estimates. It pays to call and ascertain the actual lead time.

While not as important as print media, some local radio and television stations will announce art exhibitions as part of a culture calendar or as a public service or local news event. If such stations exist in the area in which your exhibition takes place, they should be added to your media list.

Listing notices and every piece of mail sent to media should be sent by first class mail. Bulk mail is erratic and may arrive long after the deadline and, in some instances, after the exhibition. If your exhibition is at a not-for-profit space, be certain to ascertain whether they have mixed their media list in with their complete mailing list. If they have mixed the list and use bulk mailings for the complete list, you should arrange to have a separate first class mailing to media.

It is worth taking the time to compile a good media list for your

listing notices. They are the form of publicity which is almost certain of succeeding. They are inexpensive and effective. The same list, with some modification, will serve as a basis for your press release and media invitation list. Double check all of the elements that must be included in the Listing Notice. Is the phone number correct? Are there both an opening and a closing date? Now get them in the mail with plenty of lead time!

Press Releases

Press releases have a broader function than a listing notice. A press release includes all of the elements of the listing notice but, in addition, tells a story. The press release is not a substitute for a listing notice. First, it may go to a different person and, second, the listings editor would rather not search through the text of your release for the listing information.

The purpose of the press release is to obtain a story about you, your exhibition, or the subject matter of your exhibition. When sent to media that may review your exhibition, the press release should be structured to interest the critic in coming to see your exhibition.

One fact that is often overlooked is that a single form of press release will probably be inadequate to produce the results you desire. Several versions of the release may be required in order to meet the needs of the different publications to which it sent.

The straightforward press release on an exhibition will include all the elements contained in the listing notice but will do so in narrative form.

The release will provide background information about you, your work, your prior exhibitions, publications, and past reviews. If the exhibition is being held at a place that is, in itself, newsworthy, that information should be included.

The key to writing a press release is that it should get the interest of the media person who receives it. The media are inundated with press releases. Press releases are both a necessary tool for media people and a burden. To be helpful to the media is the first goal of a good press release. In the context of a press release, help means that the person receiving the release immediately senses that the information provided can be the basis of a story for his or her publication. *Fortune Magazine* is not usually interested in art exhibitions but if the artist is a corporate executive, lawyer, or accountant, and that fact is prominent in the release, the editor may see the possibiiity of an article on how a captain of industry spends his or her leisure time.

In a small town newspaper, the fact that the artist was born or went to school in the area may be sufficient to interest the editor in a story.

If your work is on the cutting edge of a new trend in the art world, that should be made clear in the release.

The following is a checklist of news release format guidelines.

1. Use one side of good-quality 8½"x 11" paper.

2. The release should be captioned "NEWS RELEASE."

3. The words "FOR IMMEDIATE RELEASE" should appear in the top right corner of the first page.

4. The method of reproduction should produce clean and legible copies. The release is your introduction to the editor.

Would you hand someone a business card that was printed with broken type or which had ink spots?

5. The release should contain a headline, in bold or capital letters, centered on the first page. Note that your headline is not necessarily what the media will use. It should be written to obtain the attention of the editor.

6. Double space the copy.

7. If the release is more than one page, the word "more" should appear at the bottom of each page but the last page. The last page should finish with the word "End" or "-30-".

The press release should contain all of the elements in the listing notice plus background on you and your art. Prior exhibitions, publications, formal training, awards, and prizes all lend credibility, but a press release is not a resume. Don't overdo it!

Since you want to immediately attract the attention of the editor, you should put the most interesting fact in the headline. The most interesting fact will vary, not only from person to person, but from publication to publication. The question the editor asks is, "Will this interest my readers?" Put yourself at the editor's desk. Think about who reads the publication and what should be in your headline. The answers to these questions will also serve to mold the facts in your opening paragraph.

The fact catching the editor's attention may be referred to as "the hook." Each day every editor receives more releases than can be used. It does help if you or your publicity person knows the editor, but it doesn't guarantee a story. The editor knows a large number of people! The best chance you have to have your release used is to have a good hook.

The larger and more important the publication, the larger the hook that is required. The fact that you live in Myakka may be a sufficient hook to make the *Myakka Gazette.* Merely living in Atlanta, Boston, New York, Chicago, Los Angeles, Houston, New Orleans, San Francisco or Washington isn't a sufficient hook for the dailies in those cities.

Big city newspapers and art magazines tend to report on and review exhibitions in museums and prominent galleries. Although that decreases the chances for coverage of other exhibitions, don't give up without trying.

Look for a section or feature of the publication that you can target. *The New York Times* has carried exhibition stories in a column called "Going Out Guide" and a Friday feature called "Weekend."

The talent for writing a press release does not necessarily come together with your talent as an artist. If your exhibition space staff has a public relations person, let that person draft the release. Your job is to supply the background material and the facts.

If you are sending your releases to a publication that uses illustrations, be certain to send along a glossy black and white photograph. If the publication is printed in color, you may increase your chances of having the picture used by sending a color print and offering to supply or pay for color separations. This is particularly true of small circulation publications with limited budgets. Separations are expensive and should not be sent unless requested. The prices for color separations vary dramatically. New technology has reduced the amounts of skill and time required for making separations. Several sources for color separations at reasonable prices are listed in **Appendix A.**

Along with the release and a glossy you may want to include copies

of prior reviews or other background material. At that point you should consider using a folder to enclose all of the material.

Few publications issue statements of advice regarding press releases. One, *Association Trends,* does issue a statement of advice. With a few changes, designed to make the advice applicable to exhibitions, their statement is:

a. **News releases** should tell the whole story (who, when, where, what, how, and how much). Use this checklist before you send any release.

b. **Name and phone number** of the originator should be on every release, and the date too. We prefer the name and phone number of the exhibition space or artist, not your PR firm.

c. **Straight facts, please**...not a fancied-up story.

d. **On time, please**...we are a [daily, weekly, monthly], not a history book, and if we don't get your information promptly it will never make our publication.

e. **Don't call us** to see (1) if we received your release and (2) if we are going to use it. We get a sackful of mail every day and we look at everything, but there's no way to track a single release. (Author's note: Take this advice with a grain of salt. What public relations persons call "follow up" and "contacts" are an important and often effective activity.)

Hiring a Public Relations Firm

If your exhibition space does not have its own public relations person and you are not equipped to do the job, you might consider hiring a professional.

If your public relations are delegated to an outside professional the budget for public relations will escalate. Public relations firms charge from a few hundred to ten thousand dollars for representation of an artist in connection with an exhibition. If your budget is slim, try trading your art for public relations services. It may work with one of the smaller firms or a freelance public relations person.

Whether the effectiveness of a professional is greater than that of a good person attached to your exhibition space or than your own efforts is debatable. It is difficult to obtain publicity, other than listings, for initial exhibitions. The major function of the person in charge of public relations and publicity will be to develop the hooks, write the press releases, and follow up with the recipients.

Follow-up takes time and dedication. Phone calls, lunches, and visits to media offices are time consuming and energy draining.

Although some artists are their own best spokespersons, others find that they cannot effectively blow their own horns. The person to do the horn blowing can be a family member, friend, or a professional.

If your budget is unlimited, by all means have the luxury of a professional. Public relations for the visual arts are related to but not identical to public relations for performing artists and business. Try to find a person or firm that has had both experience and success in handling public relations and publicity for visual artists or art institutions.

Announcements and Invitations

Exhibition announcements and invitations are discussed in a separate

chapter, but announcements and invitations are forms of publicity and public relations as well as advertising.

Keep your reasons for exhibiting in mind. If you are in an arts-related profession and are using the exhibition as a form of advertising or public relations, remember to send invitations and announcements to clients and potential clients. A follow-up phone call is perfectly appropriate. Ask whether the invitation or announcement was received and whether the recipient can attend. If there is a conflict in the recipient's schedule, remind him or her that the exhibition will run for a period of time. If it is an important client or prospective client, you can offer to meet him or her at the exhibition space at a convenient time.

Radio, TV, and Cable TV

Radio, TV, and cable talk shows may be willing to have you appear to talk about your art, particularly if there is something unique about you, your work, or the subject matter of your work.

Generally the same rules apply as for newspapers. The smaller the city, the greater the chance that you are news. Public access channels on cable television may be available, even in larger cities.

Be prepared with a hook when you contact the station. The hook is the fact or facts that make your story interesting to the talk show host and make the host believe that it will be interesting to listeners.

Summary

Publicity, other than listings, is difficult to obtain. Only the President of the United States can be certain of getting media attention, and then only

on important issues. Every release from the White House does not make it to print.

It never can be predicted what will happen. A major news event may preempt space dedicated to coverage of your exibition. On the other hand, a press release with no chance of success on a normal day may make it to print because of a dearth of news.

The cardinal rule in public relations and publicity is that nothing can happen unless you or someone on your behalf makes an intelligent and diligent effort.

Reviews

There are few absolute facts concerning exhibitions and reviews. One absolute set of facts is that (i) there are more artists than exhibitions, and (ii) there are more exhibitions than reviews.

Even large metropolitan daily newspapers, with arts and leisure sections, make no attempt to review every exhibition in their local distribution areas. A major metropolitan newspaper may even review what their critic considers to be an important exhibition in a distant city, while ignoring local shows.

Monthly art magazines contain more reviews than newspapers contain but still cover only a small fraction of all exhibitions.

Local and regional art newspapers tend to devote more coverage to emerging artists, but they do not review every exhibition.

What are the criteria for deciding to write a review? The most frequent answer from media is that reviews are accorded to important exhibitions. The word important is, of course, subjective. Your exhibition is important to you but Warhol is important to the media. What the media attitude translates to, in terms of your obtaining a review, is that to be automatically important, you probably have had several prior exhibitions which were reviewed, or you are exhibiting at a major exhibition space regularly frequented by reviewers.

Perusal of back issues of any reviewing publication will probably reveal a pattern. One common pattern is that museums and other not-for-profit spaces garner a high percentage of the space dedicated to reviews. One reason is that museums and not-for-profits plan their exhibitions well in advance and are

able to provide reviewers with advance showings (even though the exhibition has not been hung), press pictures, and color separations.

We have seen major reviewers ignore exhibitions of the works of emerging artists only to extol their talents when a major museum mounts an exhibition of the same works in a show called "New Work."

Your perusal, however, may reveal that certain publications do include reviews of the work of emerging artists.

Obtaining a review in an issue of a publication which is concurrent with the exhibition requires advance planning. The same concept of lead time that is vital to listing notices and other publicity applies to concurrent reviews.

For a monthly magazine to carry a review while the exhibition is in progress requires that the reviewer view and write about the exhibition from 60 to 120 days prior to its opening. Post-exhibition reviews, of course, are written during or after the exhibition and they appear in print at a later date.

Daily newspapers and weekend editions do not require such a long lead time. When, however, you see a review on the weekend before an exhibition opens, you can be certain that there was an early press preview or that a special showing of the work was arranged for the critic. The magazine sections of weekend editions are printed several weeks prior to their cover date. Feature stories about a current exhibition or the artist are the result of much earlier cooperation between the exhibition space and the media.

The answer, "We review important shows," is totally unsatisfactory to the emerging artist. There are several ways to increase your chances of a review.

The first way of increasing your chances of a review is to contact the critic either personally or, if you are not known to the critic, through someone

who is known to him or her. The contact should be made by a person the critic respects professionally...a teacher, curator, or exhibition space director.

While a museum may not be ready to exhibit your work, the curator of photography may be willing to recommend you as a promising artist. Your professors and teachers may have social and professional contacts with critics.

Similarly a gallery director of a major gallery, while not ready to give you an exhibition, may be willing to recommend your work to a critic.

Take advantage of every personal contact. You have nothing to lose as long as the contacts are not made in an antagonistic or offensive manner.

In the absence of a contact, you or your representative can initiate the request. Persistence, if not offensive, may pay off.

Although most art magazines deny any connection between the purchase of advertising space and reviews, it is not unknown for the advertising department to lean on the editor when the exhibition space is a regular advertiser.

Some regional art publications follow a policy of assigning a reviewer to every exhibition advertised. While a review obtained in that manner may not be as unbiased as one done without any advertising connection, it can still be used as promotional material.

There are few full-time critics. Many freelance, and frequently their submissions will be purchased by a publication, even when there has been no prior assignment.

Some artists and galleries pay freelance critics to write reviews and submit them for publication. That technique does not always work but does increase the odds. The ethical issue is whether the payment by the artist or gallery affects the type of review or merely guarantees that one is written.

Publications that do not regularly review art exhibitions may print a review if there is a special interest factor. A professional or alumni magazine may be interested in art created by their readers. The story may be about how a doctor spends leisure time or how alumni are involved with the world of art.

Photography publications may run concurrent reviews or stories that are tantamount to reviews.

Most artists will agree that a negative review is better than no review. The theory is that even negative criticism is helpful and will stimulate an equal and opposite reaction from a certain percentage of the people who view the work.

The earlier you have the work to be exhibited ready to be shown or photographed, the greater the time span in which you have the opportunity to have a review written.

The American Art Directory has a section containing a complete list of art magazines, their addresses and editors. A separate section lists newspapers carrying art notes and the names of the critics. Unfortunately, although the state is mentioned, the city and street addresses for the newspapers are omitted. That information can be obtained from *The Working Press Of The Nation* or from one of the other media directories listed in the bibliography.

Summary

Sending an announcement and an invitation to an opening is, in most cases, not sufficient to obtain a review unless the critic is a close relative. Phone

calls, personal notes, letters of recommendation and any lawful method of inducement should be used to entice critics to visit your exhibition.

While there is no doubt that every artist can find an exhibition space, it is not true that every exhibition will be reviewed.

Don't hesitate to use every contact at your disposal and at the disposal of your exhibition space to reach critics and obtain commitments for reviews.

Catalogs

Catalogs deserve separate discussion because they are both expensive and time consuming. They are not an essential part of an exhibit for an emerging artist.

Catalogs must be considered fine art books with a small number of pages. While it is true that your invitation or announcement is a reproduction of fine art, the quality of the reproduction of your work in a catalog is more inportant.

Your exhibition catalog will contain reproductions of all or a majority of the pieces in the exhibition together with biographical information. An introduction by the curator, director, or a critic is usually included.

The catalog will be used not only to identify the work on exhibit by title and date of creation, but it will also serve, after the exhibition, as your major promotional piece.

The planning for the creation of a catalog must begin before the ink is dry on the agreement with the exhibition space. In fact, the answers to the questions of who is going to prepare, pay for, and supervise the printing of your exhibition catalog must be part of the agreement.

The majority of exhibition spaces attempt to recoup the cost of the catalog by offering it for sale at the exhibition. Unless exhibition attendance is large, the cost may not be recovered. Major museum exhibitions may even turn a profit on catalog sales, but smaller exhibition spaces are fortunate to break even.

Not every attendee at an exhibition is willing or able to purchase a catalog. Depending on such factors as the total cost, the number of copies, and the projection of the number to be sold, prices may range from $1 to $25 for an exhibition catalog. At the high end you have to offer a large number of reproductions in a form that has perceived value.

While you or the staff of an exhibition space may be able to design an invitation or announcement, it requires more skill and dedication to design and produce an exhibition catalog.

Page size, format, binding, paper stock, color separations, type style, and printing process are some of the elements which combine in an end product of which either you will be proud or you will wish were never produced.

The worst mistake that can be made is to attempt to produce a catalog with too little lead time before the exhibition. The complications that arise with multiple color separations, pages of type, the acquisition of the proper stock, and printing schedules, rise geometrically from a single exhibition announcement to an exhibition catalog.

Museums and major galleries think nothing of allowing 18 months for the preparation and printing of a catalog. You should allow a minimum of nine months.

One of the first problems to arise will be that the work to be exhibited will have to be selected earlier than if there were no catalog. You must be prepared to select, title, and perhaps decide on arrangement of the exhibition at the early stages of catalog preparation.

If you intend to create new pieces for the exhibition between the execution of the agreement and the opening, it may not be wise to attempt to produce a catalog.

If arrangement is not important, you can number the pieces in the catalog and use the same numbers on the wall or identifying plaques, even if they are not sequential.

The least expensive way to produce a catalog is to work around the equipment and paper stock that your printer has in inventory.

If your design requires special printing equipment or paper you will find the cost escalating. Special equipment will limit your choice of printers. Special stock is more expensive because the printer is not buying in bulk and/or, even in bulk, it may be a substantially more expensive stock.

A professional book and catalog designer will be able to give good advice on staying within your budget. Beware of the designer whose proposals are elegant but who is unable to tell you, in advance, ball park figures for production. You will inevitably go over budget.

Some printers have customer representatives who, knowing the equipment and inventory of paper, can give invaluable advice on economies that do not sacrifice quality.

The steps in the production of a catalog include:

1. The selection of the pieces to be exhibited.
2. The selection of a print [chrome] for reproduction.
3. The writing of a description of each piece—date of creation, medium, dimensions, and title.
4. The decision on other material to be included by way of biography, introduction, and quotations.
5. The writing of the material agreed upon in item 4.

6. The designation of a person to do layout and design.

7. The making of a dummy catalog.

8. The selection of the type style(s).

9. The paper and cover stock selection.

10. The typesetting.

11. The making of color separations.

12. The preparation of mechanicals.

13. The obtaining of blues and/or press proofs.

14. The press run.

15. The delivery of catalogs to the exhibition space.

Summary

Do not be seduced by the idea of a catalog unless you and your exhibition space comprehend the amount of time, effort, skill, and money, which will be expended.

If you elect to produce a catalog, allow a minimum of nine months between the time you start work and the opening.

Special Events

Gallery Lectures for Prospective Purchasers

Galleries sponsoring lectures by exhibiting artists tend to report a correlation between sales and the presence of the artist. One theory is that there is a greater sense of identification by the potential collector with the artist if an opportunity has been afforded to know the artist, through not only the art, but his or her ideas and thoughts.

Gallery lectures are not an additional expense since the relevant information can be included on announcements and invitations. Lectures are rarely appropriate for openings. The attendees at openings want to look and socialize. Schedule gallery talks during the early evening and on weekends. One Baltimore gallery offers lectures during "brown bag" lunches at the gallery.

Lectures can be scheduled for as few as ten persons. You need only the exhibition space and some chairs. No microphone or podium is necessary. If you desire to show examples of your work that is not on exhibit, you can use a slide projector.

Lectures are not for every artist. If you are uncomfortable before audiences, or take the position that everything you have to say is in your art, then it would be unwise to schedule lectures.

In addition to your ideas and thoughts, your creative process may be of interest. If your art is created in other than traditional ways, by use of either new or different materials or tools, the subject of your lecture may be "how" as opposed to "what" or "why."

Lectures for Educators, Students, and Photographers

Your public image, if not the sales of your prints, may be enhanced by lectures delivered at the exhibition space or at other places.

Schools are often delighted to enhance their art appreciation programs by visits to exhibitions. The presence of the artist and a lecture may make the experience less mysterious to the students. Some of the students may even report the trip to their parents who, in turn, may visit your exhibition.

A trip by schoolchildren to your exhibition may serve as the basis for a story in a local paper. Remember that stories about your exhibition do not have to appear on the art page.

If your creative process is new or unusual, you may find a receptive audience among educators and other photographers.

Lectures, particularly free lectures, are often reported in the "events" columns of media. You also can use lectures to stimulate interest in a forthcoming exhibition.

Lectures are a no-cost or, at worst, a low-cost method of increasing the publicity for your exhibition and stimulating sales!

Videotapes

Videotape equipment has two possible uses in connection with your exhibition. The first is the recording of the event. The excitement of the opening, the details of the installation, the arrangement of the exhibition, and the ambiance of the gallery can be captured on tape.

That tape is not merely a personal memento. It can be used to show

your work to others and, if a potential exhibition space has playback equipment, it may be used to show your portfolio.

A second use is to stimulate interest in your work while the exhibit is on view. Your full-time presence at the exhibition space delivering lectures would be onerous, but videotapes are always present and can be played for a single viewer.

Your particular philosophy of art, your personal vision, the surroundings in which you work, pieces not on exhibit, and comments by others can be included in your taped presentation.

If the process by which your art is produced is of particular interest, you may want to videotape all or a portion, in order to be able to present repetitive demonstrations at your exhibition. Potential collectors are fascinated by the casting of a bronze, the silk screen process, the pulling of a lithograph, and the making of a dye transfer print. The more collectors understand your process and its intricacies, the more they will appreciate your work.

You can usually find a relative or friend with a videotape camera. They have all but replaced 8mm cameras, and their use is widespread. Since playback is instantaneous, you can see the results quickly enough to remedy any errors. If your budget permits a professional videotaping session, so much the better.

If the exhibition space has playback equipment, make certain you record on equipment that is compatible with the space's equipment.

If the tape is being made as a personal record of your exhibition, a script is not required. You should, however, prepare a checklist of what you want the tape to show and the sequence of the scenes.

When the tape is being made to use as part of the exhibition, a script is necessary. Although a narrated sound track can be changed, you may not

be able to convincingly dub a full-face view of yourself talking. The script or at least a sequence outline is necessary to give the person working the camera an idea of how much time should be devoted to each scene.

It is not suggested that you make a feature-length tape. A 10- to 15-minute presentation, depending on the substance of your personal vision and the complexity of the process, is a major undertaking.

Summary

Tapes are a nice touch but they are by no means essential for successful exhibits. Videotaping for use at your exhibition should be undertaken only if (i) you have the time, (ii) the making of the tape will not divert necessary energies from the preparation for the exhibit, and (iii) the tape will be of interest to those who view the exhibit.

Summing Up

There is an exhibition space waiting for you. You may not discover that space early in your search, but it exists.

Getting an exhibition requires the determination to persevere in the face of rejection. Your planning must include the possibility that an exhibition may not come easily or early.

Be realistic! While all stage actors want to play Broadway, most start in showcases, off Broadway, summer stock or repertory. Take advantage of the clout you have in your home town. Search out the galleries in metropolitan areas that have just opened and do not have a backlog of commitments. Do not hesitate to accept invitations to exhibit at alternative spaces. The experience and exposure may be more beneficial than you anticipate.

When in serious discussion with the decision-maker at an exhibition space, be reasonable in your requests. If your oeuvre is small, or the exhibition space desires to exhibit more than one artist, you may be asked to participate in a group exhibition. If the space is one with which you desire an affiliation, then by all means agree.

Be knowledgeable about the policies and financial well-being of the exhibition space. A first-rate gallery may decline to have opening parties. A not-for-profit space may be well financed and may pay for elaborate openings. Don't expect a catalog for your first exhibit. Space advertising is expensive and of questionable value for emerging artists. Listing notices coupled with mailed invitations may be more than adequate to ensure the presence of viewers at your exhibition.

Ascertain, in advance, what resources you can devote to the exhibition. During negotiations with exhibition spaces you should be in possession of a budget for the items for which you will most likely be required to pay. Do you have enough funds to move your oversized box mounted prints? Don't offer to pay for a champagne opening if funds are tight.

Keep your goals in mind. If, for instance, you are a commercial photographer using the exhibition as a way to get publicity and new clients, you may decide that an exhibition at an alternative space in the business district may be preferable to a suburban gallery. An art director at a busy agency may be willing to go ten blocks to see your work. A ten-mile trip to a gallery located in the suburbs or another part of the city may not be appealing. You will be able to get greater attendance at the alternative space.

In your quest for an exhibition space remember that every lobby in every private and public building is a potential exhibition space. The buildings owned by private clubs and special interest groups may have spaces that are perfect for your art. There is no limit on the number of alternative exhibition spaces. There is only a limit imposed by your lack of imagination, vision, and diligence in seeking them out.

Do not eliminate co-op galleries from your consideration. If you can afford membership dues and the exhibition fees, if any, co-ops should be on your list of spaces to visit and investigate. Some co-ops are located in secondary locations, and others are located in the heart of gallery districts.

Don't let the generalizations of others affect your search. Look at each space as a possibility in terms of **your reasons** for exhibiting.

Don't eliminate museums from your options. Some have regular review sessions, and a few have special rooms or galleries allocated for emerging artists.

If your goal is a commercial gallery, then do your homework; use all your contacts, and don't give up after a few sporadic attempts.

Subsidy galleries can, under some circumstances, meet all of your requirements. Their scheduling may be more flexible. They may permit you to select every piece in your show and to hang the show in exactly the manner you desire.

Keep an open mind. A co-op, subsidy gallery, or an alternative space may be exactly what you require.

There is a space waiting for your exhibition!

Appendices

APPENDIX A – SOURCES

The following is not intended as a definitive list. The sources may not even be the cheapest or the best. They do have a reputation for being reliable and certainly are not the most expensive. The omission of any source is not a negative reflection on that source. Our purpose is to supply you with a point of reference for prices and, in addition, to tell you where you can obtain services that you may require in connection with your exhibition. It is recommended that you compare the prices quoted by local printers, labs, and suppliers, against any listed source.

Color Printing

Announcements – Invitations – Catalogs – Brochures – Posters

Dexter Press – 1949 E. Sunshine, 2-210, Springfield, MO 65804, (800) 431-1095 – Dexter also has plants in West Nyack, NY, and Ontario, Canada.

Dynacolor Graphics – 1182 N.W. 159th Dr., Miami, FL 33169, (305) 625-5388.

Koppel Color – 153 Central Ave., Hawthorne, NJ 07507, (201) 427-3151.

McGrew Color Graphics – 1615 Grand Ave., Kansas City, MO 64141, (816) 221-6560.

Photographic Reproduction

Color – Black & White

Ornaal Color Photos – 24 W. 25th St., New York, NY 10010, (212) 675-3850.

Color Separations

F. P. Color Separations – 535 Fifth Ave., New York, NY 10017, (212) 490-0172.

Photoengraving, Inc. – 502 N. Willow Ave., Tampa, FL 33606, (813) 253-3427.

Spectrum Inc. – 3940 W. 32nd Ave., Denver, CO 80212, (800) 525-8149.

The following are examples of announcements and invitations. Check the elements of information in your announcement against the elements in **EXHIBITION ANNOUNCE-MENTS AND INVITATIONS.** The proofreader should not be the same person who ordered the type and did the mechanical. There is a tendency to miss the same error over and over again. A stranger to the copy and layout will bring a more discerning eye.

Example 1 – This is an example of an announcement and invitation produced in color by photographic printing on color print paper. The information was set in type and the composite negative of type and image printed.

nomads of the sinai

Photography by
BENI GLASER

Sept. 23 - Oct. 18

Opening
Sept. 23 5 - 7 pm

**20/20 Photographer's Place
20 West 20
New York, NY 10011**

Daily 12 - 6 pm (212) 675-2020

Example 2 — This is an example of an invitation produced as a postcard. The reverse side is in full color with a white border containing a copyright notice and the photographer's signature. The exhibition is at an alternative space. The opening reception date is provided, but the exhibition dates have been omitted.

The Commissioners of the Port Authority
of New York and New Jersey
invite you to join

Ruffin Cooper, Jr.

at the preview of his Photo Banners

It's An Illusion
and
New York - New Jersey

Reception

Thursday, February 21, 1985
11:00 A.M.

Port Authority Bus Terminal
South Wing
Mezzanine, at Main Escalators

625 Eighth Avenue
New York, New York 10048

Example 3 – This announcement and invitation was produced as a black and white postcard. The reverse side contains the image. By omitting a box for the stamp on the right-hand side of the card and the vertical rule common on postcards, the announcement has been made suitable for use as a postcard or an enclosure in an envelope. When mailed in an envelope, the right-hand side of this card may be used for personal notes. If the opening reception were to be limited in size, the printed reception information could have been omitted and invitations written on the right-hand side. The exhibition is at an alternative space.

WASHINGTON HEIGHTS-INWOOD:
VIEWS 1934-1952

14 Images from the Parks Photo Archive
Curated by Gerard Malanga.
Text by Catherine A. Christen,
Assistant Park Historian.

Monday, Dec. 1 thru Dec. 30, 1986
Fort Washington Library
535 West 179th Street
(bet. St. Nicholas/Audubon Aves.)

Monday, Feb. 9 thru March 9, 1987
Washington Heights Library
1000 St. Nicholas Ave & 160th St.

Sponsored by the New York Public Library
in conjunction with
City of New York
Parks & Recreation
Edward I. Koch, Mayor
Henry J. Stern, Commissioner

Photo by Rodney McCay Morgan,
Fort Tryon Park, 1941.

APPENDIX C - FORM OF PRESS RELEASE

The sample press release contains all of the elements required in a press release. The text is straightforward. What is missing, if anything, is a hook to catch the attention of the editor. The hook should give the editor a story line as opposed to a simple recitation of the facts related to the exhibit.

FOR: IMMEDIATE RELEASE

PRESS RELEASE

CONTACT: PHILLIP BLOOM, PR
(212) 243-5363

ARMSTRONG

HARRIET LEBISH, DIRECTOR

GALLERY RITA SILVERSTEIN
CONTACT: (212) 582-8581

ARMSTRONG GALLERY IN EARLY FALL START
TWO EXHIBITIONS OPEN SATURDAY, SEPTEMBER 7TH

The Armstrong Gallery, 50 West 57th Street, will inaugurate its major Fall season on Saturday, September 7th, with two exhibitions, Ian Hornak, the landscape painter, and in our West gallery, the color photography of David Graham. Each is a debut with the gallery and will remain on view through October 2nd.

Ian Hornak will show sixteen works, many of them acrylic on canvas, others on wood and masonite ranging in size from 6½' x 4½' to smaller sizes of 24" x 30". Hornak's most recent work indicates an important and innovative direction to his familiar meticulously crafted landscapes and figure painting, based on abstraction and symbolism. The artist calls this forthcoming exhibition "Mysterious Bounderies" and incorporates another aspect of traditional art in his work, the painted frame, which is an integral and necessary transcendence of the image beyond the boundary of the canvas.

At age 32, David Graham is a seasoned veteran of the photographic medium, having spent half his life in photography. Introduced to the camera by a school friend he was soon competing in contests, spurred on by an award from the Erie Pennsylvania Art Museum, who then purchased the photograph. Since that occasion, Graham's unique perceptions have made him well qualified to record our society with the eye of both the sociologist and archeologist. His meticulous and detailed photographs are now in the permanent collection of the Museum of Modern Art, the Chicago Art Institute, the Philadelphia Museum, and the Houston Museum of Fine Arts. His work is included in numerous museum and corporate collections around the country. Gallery hours are Tues - Fri. 10:00 to 5:30, and Sat. 11:00 to 5:30.

50 WEST 57TH STREET, NEW YORK, NY 10019 (212) 582-8581

Photographer–Exhibition Space Agreement

The Parties to this Agreement are _____ who resides at _____ (the "Photographer") and _____ located at _____ _____ (the "Exhibition Space").

1. (a) The Photographer will exhibit at the Exhibition Space between _____ and _____ inclusive.

(b) The exhibit will be a solo [] group [] exhibition.

(c) Photographer will exhibit _____ works of art occupying no less than _____ linear feet on the walls of the Exhibition Space. The Photographer's medium is _____ . The work to be on display is "the Art."

2. (a) The Art will be delivered to the Exhibition Space by the Photographer at the expense of Photographer [] Exhibition Space [] between _____ and _____ during the normal business hours of the Exhibition Space.

(b) Unsold Art will be removed from the Exhibition Space between _____ and _____ during the normal business hours of the Exhibition Space at the expense of Photographer [] Exhibition Space [].

(c) If required, the Art will be framed by Photographer [] Exhibition Space [].

(d) The Art will be hung by Photographer [] Exhibition Space [] with final approval being the right of the Photographer [] Exhibition Space [].

(e) Lighting the exhibit will be the responsibility of Photographer [] Exhibition Space [].

(f) The following special security arrangements have been agreed upon:

and will be paid for by Photographer [] Exhibition Space [].

3. (a) There will be an opening of the exhibit: Yes [] No [].

(b) The opening will be on _____ from _____ to _____ .

(c) Refreshments, if any, will be the responsibility of and paid for by Photographer [] Exhibition Space [].

4. (a) Invitations to the opening, if any, and the exhibit announcements shall be designed and printed at the expense of Photographer [] Exhibition Space []. The party not paying for the invitations shall have the right to approve copy and design: Yes [] No [].

(b) The party paying for the printing shall supply _____ invitations to the other party for their use.

(c) The invitations shall be sent by first class mail [] bulk rate [].

(d) Postage shall be paid by Photographer [] Exhibition Space [].

5. (a) The preparation and mailing of listing notices shall be the responsibility of Photographer [] Exhibition Space [].

(b) The preparation and mailing of press releases shall be the responsibility of Photographer [] Exhibition Space [].

(c) There will be newspaper and/or magazine advertising: Yes [] No [].

(d) If the answer to (c) is Yes, the names of the publications, space size, and number of insertions agreed upon are as follows:

(e) The expense of newspaper and/or magazine advertising will be paid by Photographer [] Exhibition Space [].

(f) There will be an exhibition catalog: Yes [] No [].

(g) The responsibility for the preparation of the catalog is that of Photographer [] Exhibition Space [].

(h) The cost of type, half tones, color separations, design, and printing shall be paid by Photographer [] Exhibition Space [].

6. Title to the Art while on the premises of the Exhibition Space shall remain in the Photographer: Yes [] No [].

7. (a) Risk of loss of the Art while at the Exhibition Space, for any reason, including but not limited to vandalism, fire, or theft, shall be that of the Photographer [] Exhibition Space [].

(b) Art will be insured while at the Exhibition Space: Yes [] No [].

(c) If the Art is to be insured it shall be insured under an all risk policy in the amount of $ _____ .

(d) The premium for insurance, if any, shall be paid by Photographer [] Exhibition Space [].

8. (a) The Art shall be offered for sale by the Exhibition Space: Yes [] No [].

(b) The Exhibition Space will receive a commission on the sale of the Art: Yes [] No []. The commission payable, if any, shall be _____ %.

(c) If there are to be sales of the Art the sales price of each work shall be fixed by Photographer [] Exhibition Space [] mutual agreement between Photographer and Exhibition Space [].

(d) The party collecting the sales price, if any, shall pay the portion of the sales price to which it is not entitled to retain, to the other party within [number] days of receipt of the payment.

(e) If Photographer receives a special commission for work to be created as a result of the exhibition, will the Exhibition Space be entitled to a percentage of the fee? Yes [] No []. If the answer is Yes, the Exhibition Space shall receive _____ % payable within [number] days after receipt by Photographer of payment.

9. (a) Is Exhibition Space guaranteeing any minimum payment or sales to Photographer? Yes [] No []. If the answer is Yes, the amount payable is $ _____ and shall be paid on or before [date].

(b) Is the Photographer obligated to pay for use of the Exhibition Space? Yes [] No []. If the answer is Yes, the Photographer shall pay $ _____ to the Exhibition Space on or before [date].

10. (a) Subsequent to the exhibition will the Exhibition Space act as a dealer for Photographer? Yes [] No [].

(b) If the answer is Yes, will the sales commission remain the same as that payable during the exhibition? Yes [] No []. If the answer is No, the new commission will be _____ % and will be paid on sales occurring subsequent to the [number] day after the close of the exhibition.

(c) If there are to be sales of the Art, the sales price of each work shall be fixed by Photographer [] Exhibition Space [] mutual agreement between Photographer and Exhibition Space [].

(d) The party collecting the sales price, if any, shall pay the portion of the sales price to which it is not entitled to retain, to the other party within [number] days of receipt of the payment.

(e) Post-exhibition representation, if any, shall continue for a period of [number] months from the end of the exhibition.

11. (a) Photographer hereby grants to Exhibition Space the right to use his/her name, likeness, and reproductions of the Art in advertising and promotion.

(b) Photographer represents to Exhibition Space that (i) the Art is original work and that the copyright is owned by Photographer, (ii) any required model releases and/or permissions to use the incorporated work of third parties have been obtained in writing and written copies are in the possession of Photographer, (iii) the Art is owned by Photographer free and clear of all liens and encumbrances, and (iv) if the Art is a multiple requiring a disclosure document under the law of the state in which the Exhibition Space is located, Photographer has supplied complete and accurate information to the Exhibition Space sufficient for compliance with such disclosure law.

(c) Exhibition Space agrees not to loan, rent, or subconsign the Art without the prior written consent of Photographer.

(d) Exhibition Space agrees that it will not permit the Art to be copied, photographed, or reproduced except as permitted in this Agreement, without Photographer's prior written consent.

(e) Exhibition Space agrees that included in each bill of sale will be the following legend: "All rights to reproduce the work(s) of art conveyed hereunder are retained by the artist."

12. This instrument contains the entire Agreement of the Parties relating to the subject matter hereof, and the Parties have made no agreements, representations or warranties relating to the subject matter of this Agreement which are not set forth herein. No modification of this Agreement shall be valid unless made in writing and signed by the Parties hereto.

13. This Agreement shall be deemed to have been made under, and shall be governed by, the laws of the state where the Exhibition Space is physically located.

14. Any controversy or claim arisiing out of or relating to this Agreement, or the breach thereof, shall be settled by artbitration in accordance with the Commercial Arbitration Rules of the American Arbitration Association in the City of _____, State of _____, and judgment upon the award rendered by the Arbitrator(s) may be entered in any Court having jurisdiction thereof.

Dated: _____ _____
 Photographer

 (Exhibition Space)

 by _____
 (Name—title)

Copyright © 1987 The Photographic Arts Center

APPENDIX E—EXHIBITION CHECKLIST

1. Contacting and Visiting Exhibition Spaces
 a. phone charges
 b. postage required to mail and obtain return of "portfolio"
 c. transportation costs
 d. food and lodging for out-of-town trips
2. Preparing Your Art for Your Exhibition
 a. materials for additional pieces required for the exhibition
 b. mounting and framing
 c. lighting fixtures if space is inadequately lit
3. Delivery and Return of Your Art
 a. delivery charges or rental of van
 b. insurance while in transit
 c. labor charges if you are unable to handle your art without help
4. Legal Advice in Connection with Agreement with Exhibition Space
5. Postage
 a. listing notices
 b. press releases and press kits
 c. invitations and announcements
6. Printing
 a. invitations and announcements
 b. exhibition brochure or catalog
 c. photocopy costs for listing notices and press releases
7. Publicity and Public Relations
 expenses other than postage and photocopy costs—e.g., press person, prints and color separations
8. Advertising
 a. ad preparation
 b. media
9. Insurance
 a. on art while at exhibition space
 b. liability insurance if exhibition space isn't insured
10. Special Security Arrangements
11. Opening Reception
 a. refreshments
 b. labor charges for servers, cleanup, and building personnel
12. Exhibition Space Fee
 a. co-op charges
 b. space rental at subsidy gallery
13. Out Of Town Exhibition Costs
 travel, food and lodging

J. L. "WOODY" WOODEN
1505 Grand Ave.
Santa Barbara, CA. 93103 (805) 966-3275
 965-6415

Education:
1969-1968 Photojournalism, Phoenix College; Phoenix, AZ.
1971-1969 Brook's Institute of Photography; Santa
 Barbara, CA.
1971 Santa Barbara Art Institute
1979-1978 Natural Resourses Management, A.A.S.; Pima
 Community College; Tucson, AZ.
1978 Studied photojournalism under W. Eugene Smith
 at the University of Arizona; Tucson, AZ.

Museum and Gallery Exhibitions:

1980 Murphy-Rochester Gallery; Midland, TX.
1982-81 The Hanging Tree Gallery, Midland, TX.
1986-83 Nadja's; Edmonton, Alberta; Canada
1983 Western States Museum of Photography; Single
 Artist Showing; Santa Barbara, CA.
1984 The Flandrau, University of Arizona; Tucson.
1986-84 Astra Gallery; Santa Barbara, CA.
1985 Lyon Gallery; Redlands, CA.
1985 Redlands Art Association; Redlands, CA.
1985 2nd Annual Erotic Exhibit; Astra Gallery;
 Featured Artist, Santa Barbara, CA.
1985 Energy Awareness Exhibit; U.S. Department
 of Commerce; Washington, D.C.
1986 2nd Annual Innovations Exhibit; Astra Gallery
 Featured Artist, Santa Barbara, CA.

Future Exhibits:
1986 Southern California Museum of Science and
 Industry, Los Angeles – June 2nd to Sept.
 4th.

1986 Lightning exhibit to be installed at the
 California Academy of Sciences; Golden Gate
 Park; San Francisco.
1986 Kelowna Centennial Museum; Kelowna, British
 Columbia; Canada – Nov.– Dec. the overall
 theme is on the Southwestern U. S.
1987 20 year retrospective exhibit, February, Astra
 Gallery, Santa Barbara, CA.

Grants:
1976-75 Pima Community College; To study Abandoned
 mining towns in Arizona.

Permanent Collections:
 Pima Community College Art Collection; 100
 highly polished aluminum prints of Aband-
 oned mining town in Arizona.
 Western States Museum of Photography;
 A selection of Selenium Lightning prints
 from the "Dancing Light" Exhibition.
 California Academy of Sciences; Golden Gate
 Park; San Francisco. Lightning Images.

Private Collections throughout the United States and in
 Argentina, Australia, Canada, England,
 Japan, Norway, Lebanon, Thialand and West
 Germany.

Teaching Experience:
 1978-77 Photo Depot Gallery; Numerous seminars on
 Nude and Figure photography; Tucson, AZ.
 1981-80 Odessa Junior College; Practical Photography;
 Odessa, TX.

Awards:
 1970 University of California at Santa Barbara's
 People Photo Contest. 2nd and 3rd place
 winner.
 1973 Wyoming Wildlife Magazine's Annual Photo
 Contest. Historical Division, 1st place.
 1985 "AMERICAN ENERGY PICTURE" National Photo
 Contest. 2nd place color category.
 U.S. Dept. of Energy; Washington, D.C.
 1985 The Maine Photographic Workshops Annual
 Photographic Show. Honorable Mention.

Commercial Publication Agents:

Black Star Publishing Co. American Stock Photos
450 Park Avenue South 6842 Sunset Blvd.
New York, New York Los Angeles, California

Bibliography

American Art Directory (50th Edition) — R. R. Bowker — New York, NY — 1984

Art In America—Annual Guide To Galleries, Museums, Artists — Whitney Communications — New York, NY — Annual

Art Marketing Handbook — Calvin J. Goodman — Gee Tee Bee — Los Angeles, CA — 1978

Bacon's Publicity Checker — Bacon's — Chicago, IL — Annual

Contracts For Artists — William R. Gignilliat, III — Words Of Art, Inc. — Atlanta, GA — 1983

Gallery Guide — Art Now Inc. — Kenilworth, NJ — Monthly

Guide To Artist-Gallery Agreements — Philadadelphia Volunteer Lawyers for the Arts and Lawyers for the Arts Committee — Philadelphia, PA — 1981

Gebbie's All-In-One Directory — Gebbie Publishing — New Paltz, NY — Annual

How to Photograph Works of Art — Sheldan Collins — American Association for State and Local History — Nashville, TN 37201 — 1986

Making A Living In The Fine Arts — Curtis W. Casewit — Macmillan — New York, NY — 1981

Model Agreements For Visual Artists—A Guide to Contracts in the Visual Arts — Paul Sanderson — Canadian Artists' Representation Ontario (CARO) — Ontario, Canada — 1982

N. W. Ayer & Son's Directory Of Newspapers And Periodicals — N. W. Ayer & Son — Philadelphia, PA — Annual

Promoting & Selling Your Art — Carole Katchen — Watson-Guptill Publications — New York, NY — 1978

Publicity: How To Get It — Richard O'Brien — Harper & Row — New York, NY — 1977

Quick & Easy Way To Photograph Art — Ed Peterson — Modern Photography — New York, NY — July 1977

The Artist-Gallery Partnership—A Practical Guide To Consignment — Susan Mellon and Tad Crawford — American Council For The Arts — New York, NY — 1981

The Official Museum Directory — American Association Of Museums & National Register Publishing — Washington, DC — Annual

The Photographer's Complete Guide To Exhibition & Sales Spaces — Peter H. Falk — The Photographic Arts Center — New York, NY — 1985

The Standard Periodical Directory — Oxbridge Communications, Inc. — New York, NY — Biennial

The Working Press Of The Nation — Four volumes: *Newspaper Directory; Magazine Directory; Radio & TV Directory; Feature Writer and Syndicate Directory* — National Research Bureau — Burlington, IA — Serial revisions

This Business Of Art — Diane Cochrane — Watson-Guptill Publications — New York, NY — 1978

Index

ORDER FORM

How Many Copies? **Risk Free Guarantee: You may examine any book for 2 weeks. If, for any reason, you are dissatisfied you may return it and receive a full refund.**

1. _____ THE ARTIST'S GUIDE TO GETTING & HAVING A SUCCESSFUL EXHIBITION
ISBN 0-913069-04-3 ... @ **$24.95** = _____

2. _____ THE PHOTOGRAPHER'S COMPLETE GUIDE TO EXHIBITION & SALES SPACES
ISBN 0-913069-06-x ... @ **$19.95** = _____

3. _____ THE PHOTOGRAPHER'S GUIDE TO GETTING & HAVING A SUCCESSFUL EXHIBITION
ISBN 0-913069-10-8 ... @ **$24.95** = _____

4. _____ THE PHOTOGRAPH COLLECTOR'S RESOURCE DIRECTORY – Second Edition
ISBN 0-913069-05-1 ... @ **$24.95** = _____

5. _____ THE PHOTOGRAPHIC ART MARKET: AUCTION PRICES 1985
ISBN 0-913069-09-4 ... @ **$49.95** = _____

6. _____ THE PHOTOGRAPHIC ART MARKET: AUCTION PRICES 1982/84
ISBN 0-913069-03-5 ... @ **$69.95** = _____

7. _____ THE PHOTOGRAPHIC ART MARKET: AUCTION PRICES 1981/82
ISBN 0-913069-03-6 ... @ **$49.95** = _____

8. _____ THE PHOTOGRAPHIC ART MARKET: AUCTION PRICES 1980/81
ISBN 0-940926-00-8 ... @ **$29.95** = _____

9. _____ Subscription to THE PHOTOGRAPH COLLECTOR
ISSN 0271-0838 ... @ **$125.** = _____

10. _____ THE ARTnews GUIDE TO TAX BENEFITS FOR COLLECTORS, DEALERS & INVESTORS
ISBN 0-913069-07-8 ... @ **$79.95** = _____

11. _____ STOCK PHOTO & ASSIGNMENT SOURCE BOOK – Second Edition
ISBN 0-913069-01-9 ... @ **$29.95** = _____

12. _____ MATTING & HINGING OF WORKS OF ART ON PAPER
ISBN 0-913069-11-6 ... @ **$10.00** = _____

Subtotal $ _____

Postage & Handling @ $2. per volume $ _____

NYS Residents add sales tax $ __ **Total** $ _____

☐ **Check Enclosed*** ☐ **Charge my Visa MC, or American Express Card.**

Card # _____

Expiration date _____

Ship to:

Name: _____

Address: _____

_____ **Zip** _____

*Please make checks payable to Photographic Arts Center. Checks must be payable in $US on bank in US. For airmail delivery outside North America add $6.50 per volume. The Photographics Arts Center, 127 East 59th St., New York, N.Y. 10022 (212) 838-8640.